VICTORIANA

Frontispiece: A selection of mid-Victorian pot-lids.
Top left, *The Village Wedding,* top right,
Shakespeare's House. Centre top, Pratt pomatum
pot lid, with a Victorian love scene; centre
below, *Pegwell Bay.* Bottom left, Pratt pomatum
pot lid of *The Finish of the Derby.* Bottom right,
Pratt fish paste pot lid, *Fishing Boats at Sea.*

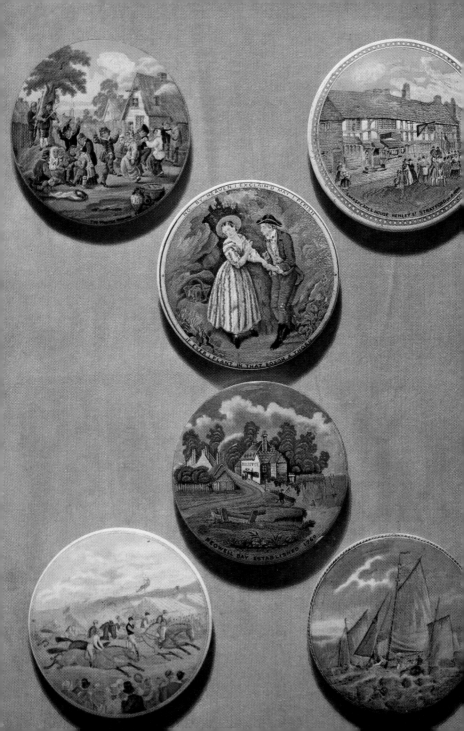

VICTORIANA

by
James Laver

HAWTHORN BOOKS, INC.

Publishers · New York

570683

First American Edition, 1967

Acknowledgments

The author and publishers are indebted to the following for the use of illustrative material in this book.

Bethnal Green Museum 230–236; Bath Museum of Costume 66, 68, 70, 72, 74, 76; Birmingham Museum and Art Gallery 1, 14, 18, 20, 28; W. T. Copeland & Sons Ltd. 160, 162, 163; Cameo Corner 145–156; Cole & Son 211; The Collectors Guide, D. C. Monk and M. H. Impey: Colour Frontispiece; W. G. Davis 2; Doulton & Co. Ltd. 171; Mrs. de Vere Green 137–144; David Drummond, Pleasures of Past Times 77–81, 83, 85, 119–126; Geoffrey Godden 161; Radio Times Hulton Picture Library 214, 219, 237–245, 248, 249, 251, 262; John Hall: Cover, 8, 98–118, 166, 167, 201, 258–259; Illustrated London News 47; Simon Kaye Ltd. 189, 191–196; London Museum 86–90, 92, 93, 95, 96, 127, 129–136; London Transport Executive 253; Ian Macdonald 209; Ministry of Public Buildings and Works 38, 42; Mrs. D. Langley Moore 64, 65, 67, 69, 71, 73, 75; William Morris Gallery, Waltham Forest 6, 60, 173, 208, 212; Marjorie Parr 175, 177, 178, 180, 182–187; Redmond Phillips 213, 255–257; Russell Cotes Art Gallery & Museum, Bournemouth 41; Salford Museum and Art Gallery 5; Science Museum 215, 217, 218, 220, 221, 246, 247, 250, 252, 254, 261; S. J. Shrubsole Ltd. 190; Tate Gallery 4, 13, 15–17, 19, 21–27, 29–36, 40, 43, 44; Victoria and Albert Museum 37, 39, 45, 158, 159, 172, 174, 181, 188, 197, 198, 203–207, 216, 223, Back Cover; The Wall Paper Manufacturers Archives 210, 260; Josiah Wedgwood & Sons Ltd. 165; Worcester Royal Porcelain Co. Ltd. 157, 164; Lionel Young Antiques 9, 168–170, 179, 199, 200, 202, 263.

Printed in Great Britain by The Whitefriars Press Ltd., London and Tonbridge.

PREFACE

The problem in writing of "Victoriana" is to know when to stop. After all, the Victorian Age covered nearly three-quarters of the nineteenth century and left an indelible mark on every aspect of life, not only in these islands. A great many of us still live in Victorian houses – or in parts of Victorian houses; for those were "spacious days", at least in the domestic architecture of the middle classes. As one travels from the centre of London to its outer suburbs one encounters a whole series of almost concentric rings, like the rings of the cross-section of a tree, showing quite clearly what was built in the 'sixties, the 'eighties and at the end of the century. Even a summary account of Victorian architecture would need a far larger volume than this.

The French make a useful distinction between *meubles* and *immeubles*: we have left out the *immeubles* altogether, and chosen to concentrate upon those products of the Victorian Age which fall into the category of what the late William Thorpe, in his studies of furniture, called "moveable history".

For history it is. The chairs on which our great-grandmothers spread their crinolines, the "chimney glasses" which reflected their demure coiffures and their unpowdered faces, the jardinières in which they arranged the flowers, the vases which bedecked their rooms, the glass and silver on their dinner-tables, the paper-lace valentines and the Christmas cards which they received at the appropriate seasons, the toys their

children played with: in fact the whole intimate décor of their lives – these are the things we have endeavoured to present. It would be an over-simplification to say that the book is aimed merely at collectors of "Victoriana". It is hoped that it will appeal also to all who are interested in an age, so very recent in the perspective of history, and yet so very different from our own.

CONTENTS

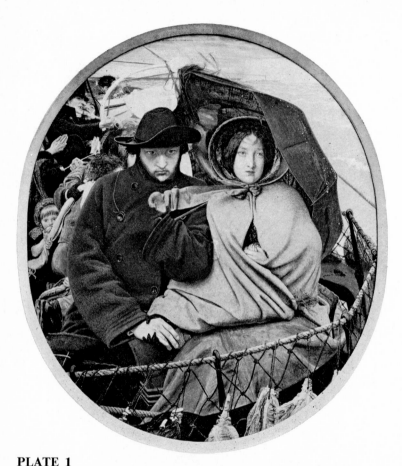

PLATE 1
Ford Maddox Brown (1821–1893): *The Last of England*. The departure
of the disillusioned Pre-Raphaelite sculptor Woolner for Australia
in 1851 gave Brown the idea for this picture. Brown was an
associate of the Pre-Raphaelites, and became the "godfather" of
the movement. His highly original style often gives his characters
the appearance of brightly coloured cut-out figures. In addition
to his oil paintings he designed glass and furniture for Morris,
Marshall, Faulkner & Co., and completed twelve frescoes for
Manchester Town Hall.

THE VICTORIAN AGE

Forty years ago, the word "Victorian" was simply a term of abuse; it stood for all that was stuffy, heavy, and overladen with ornament. Lytton Strachey, in his wickedly urbane *Eminent Victorians*, had just demonstrated that the Victorian Age was not only all these things but ridiculous as well. No one dreamed of collecting "Victoriana", no one, that is, except Arnold Bennett, who was thought extremely eccentric and even a little perverse, for his interest in papier-mâché furniture with scenes of Balmoral by moonlight in inlaid mother-of-pearl. Now, a generation later, all that is changed. Today papier-mâché tables and chairs command high prices in the sale-rooms; ball-fringes can sometimes be seen on the most sophisticated curtains; even wax fruit has come back into favour. All these, together with bead-embroidered footstools, japanned ink-stands and paper-lace valentines, have acquired a "period charm". People are even beginning, with a certain wry smile, to admire examples of Victorian anecdotal painting: shaggy dogs gazing mournfully at the coffins of their dead masters, angelic infants giving away their dolls to ragamuffins, the wives of fishermen (or the mothers of prodigals) eternally gazing out of windows into the darkness, pink angels, old women in church, gamblers' wives, fallen idols, thatched cottages, dying children – those are beginning to be treasured once more.

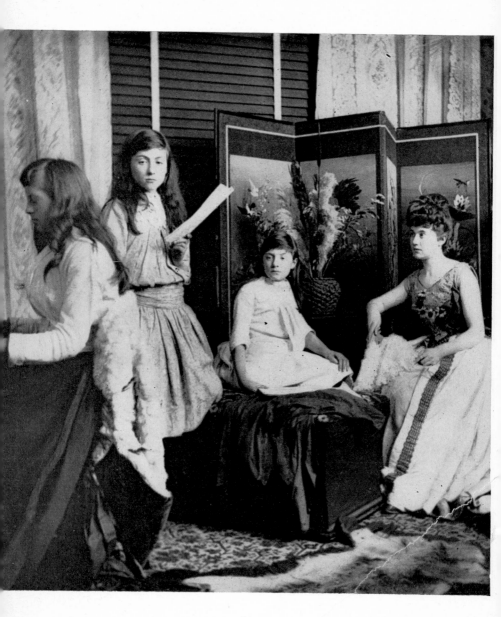

PLATE 2
This early photograph of a
Victorian musical evening,
showing the family gathered
round the piano to hear the
daughters play and sing under
the surveillance of "Papa",
illustrates the leisurely and
well-ordered pursuits of the
Victorian drawing-room.

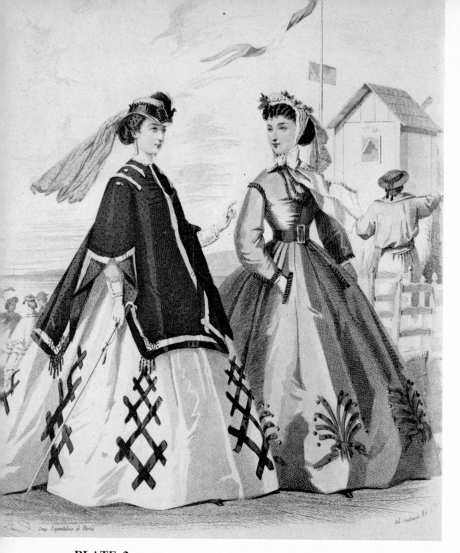

PLATE 3

Fashion plate from *The Englishwoman's Domestic Magazine*, 1865,
by Jules David (1808–1892). The magazine was founded by
Samuel Beeton in 1852, and began to import coloured fashion
plates from France in 1860, happily selecting Jules David, who
worked for *Le Moniteur de la Mode*, and whose plates show not
only fine detail in the clothes themselves, but also in
the background detail of furniture or country scenes.

This raises one of the most difficult questions in the psychology of taste. We like to think that taste is static, and what we admire today would always have been admired if only our ancestors had been educated up to it. We like to think that beauty and ugliness are objective realities, eternal in the heavens, unchanging although the skies should fall. The truth is, unfortunately, very different.

It is very instructive in this connection to study the history of feminine fashions; that is, the department of the applied arts which is most easily *and most visibly*, influenced by "Fashion". It seems to be a law of our own minds that the fashions of our mothers are hideous, the fashions of our grandmothers quaint, the fashions of our great-grandmothers charming, and the fashions of our great-great-grandmothers beautiful. Anyone can check this for himself by looking through a historical sequence of fashion-plates. But the same law operates, at a slightly larger remove, in all the other applied arts. It is equally true of furniture and interior decoration. There is an incapacity to appreciate what lies immediately behind us and a readiness to accept (and even to pay highly for) what lies further back. The "second-hand" and the "old-fashioned" gradually take on the patina of the "antique".

It almost seems as if there were a *Gap in Appreciation* stretching across a given number of years, and that the inevitable way for furniture dealers to make a fortune would be to buy up everything they could lay their hands on a few years ahead of public taste. Indeed, this is precisely what has happened. Early collectors of Chippendale and Empire furniture *have* made fortunes, just as early collectors of Victoriana knick-knacks have already begun to do. One ought to lay down furniture for one's children just as our ancestors laid down wine, in the firm conviction that with the passage of the years it will inevitably mature.

But this, of course, is too simple an approach to the problem. If everybody kept everything from one generation to another, there would be no rarity value in the works that survived. The

PLATE 4
Augustus Egg (1816–1863): *Past and Present* – a triple picture
of a faithless wife. Egg was an excellent actor and played in
Dickens's company of amateurs, but it was his small anecdotal
pictures that made him famous.

Gap in Appreciation not only enables designers to throw off the
burden of the immediate past and to move forward to the
creation of a new style, it *spaces out* the surviving objects, and
so makes it possible to collect them. It is with these surviving
objects from the Victorian Age that we are here concerned.

How are we to distinguish the good from the bad ? Many of
the products of the age must, one fears, be consigned to the
category of what has been half-humorously called "Good Bad
Art". According to this classification there are four categories
of artistic achievement: Good Good Art, Bad Good Art, Good
Bad Art and Bad Bad Art. The problem can be simplified by
discarding the two extremes. Good Good Art – the accepted
masterpieces – lies outside the scope of our enquiry; and as for
Bad Bad Art there is nothing to be said for – or about – it. Bad
Good Art, on the other hand, is all too plentiful. It is produced
by worthy men who know all there is to know about how a

picture should be painted and spend their lives trying to paint like the accepted artist of the moment – or of the moment before. It includes all those canvases on the walls of the more advanced galleries, constructed according to the fashionable formula and far more dead than the carcases in a butcher's shop, for even maggots would not breed in them. Perhaps it is the sense of wasted effort that induces the boredom one feels in their presence.

But we are not bored with the products of Good Bad Art: the valentines, the tinsel pictures, the "Presents from Margate", unpretentious and, in the minds of their makers, not falling into the category of art at all. Certainly none of their purchasers thought of them as art, "high" or "decorative", and when their immediate purpose was served, they were simply destroyed or thrown away. Yet such as have survived turn out to have a curious vitality, a life of their own, for they come to us charged with all the flavour of an epoch, the perfume of the Past. They acquire a charm in our eyes, even a beauty, they attain to something of the prestige of the "period piece". No age was richer in this kind of thing than the Victorian age.

But what do we mean, exactly, by Victoriana? The young

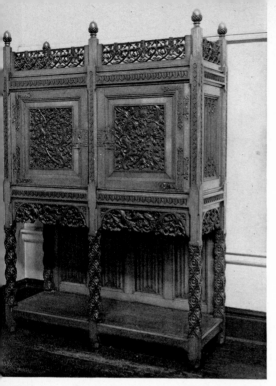

girl who came to the Throne in 1837 and whose reign lasted
sixty-four years, saw, in her long span, some considerable
changes in taste. At the beginning the style of the Regency was
not yet quite extinct; the end saw the advent of Art Nouveau.
The term Victoriana means, to most people, the art products of
the first half of Victoria's reign, that is, from about 1840 to
about 1870. This was the period of solid mahogany, heavy
curtains and upholstery, sombre and richly-patterned wallpaper
and carpets, huge pictures in elaborate gilt frames. It was against
all this that William Morris revolted and, by the 'eighties, his
influence had spread to the houses of all "advanced" people.
Whistler too with his passion for light yellow walls, small
pictures in narrow frames, light, even spindly, furniture, bull-
rushes and peacocks' feathers in tall vases, screens and Japanese
fans, had made his impact felt. Together, they produced the
Aesthetic Movement. Our survey must take some account of

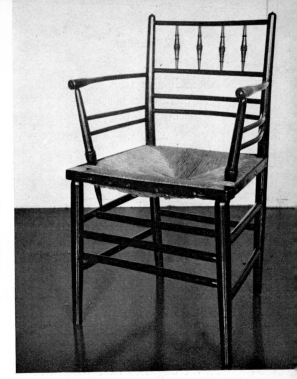

PLATE 6
William Morris (1834–1896):
"Sussex" chair of ebonised
beech with rush seat based
on a type found in Sussex,
made and popularised by
Morris, Marshall, Faulkner
& Co. from about 1865.
Morris's main interest was
in flat pattern for books,
furniture, and fabrics, but
those who designed furniture
for the firm were influenced
by his preference for
simplicity and functionalism.

this, but it is not the dominant flavour of the epoch considered as a whole.

That dominant flavour was essentially *bourgeois*, which (we have to remind ourselves) is not necessarily a term of abuse. The taste of the nineteenth century was dictated by the middle classes just as the taste of the eighteenth century had been dictated by the aristocracy. It was moreover an urban taste. The typical Englishman was no longer John Bull the country squire; he was a business man, and on every day but Sunday he toiled "in the City". And until about the middle of the century he lived there too. And then he took a momentous decision: to separate his place of work from his home; to live no longer, so to speak, "over the shop".

Anyone who visits London, even today, must be struck by the quite prodigious number of houses, in Kensington and similar neighbourhoods, with a portico and two pillars. All

V—B

these houses were built in the 1850s and early 'sixties and represent an almost universal trek to the west.

Nothing is more typical of the Victorian Age than these houses. They were very large houses by modern standards; by all previous standards they were, owing to the high cost of land, very narrow houses. They were houses on end. The rooms were arranged on top of one another, and this was the vital fact.

Great as had been the social division in the typical eighteenth-century house, masters and servants were much more, at least in the physical sense, on the same level. Now that society was confronted with a perpetual symbol of its hierarchical structure, the servants became, quite literally, the "lower classes". "High Life below stairs", chuckled the satirists, rejoicing in what seemed to them a daring paradox.

"Below stairs" were the kitchens, pantries, larders, sitting-room for the servants – if any such was provided. On the ground floor (raised, usually, above the ground and reached by an imposing flight of steps) the domain of gentility began.

We ought to have written the word Gentility with a capital G, for we shall never understand the Victorians until we realise the importance of the idea of gentility. Parodying Gibbon, one might call it "the ghost of aristocracy standing bare-headed beside the grave thereof". But in another sense it was a con-spiracy *against* aristocracy, a claim that all *gentlemen* are equal even if one of them is George, Prince of Wales, and one of them George Brummel.

Beau Brummel's notion, of course, was that no "gentleman" could engage in Trade, and it is odd that this idea should have remained so powerful a generation later when the business men had taken over. With the odd exception of being a wine mer-chant, there was a certain stigma in being engaged in any kind of gainful occupation; but it was only *because* he was thus engaged that the Victorian *bourgeois* could afford to live in one of the fine new houses in Cromwell Road. The best he could do was to ensure that at least his wife and daughters did nothing useful.

PLATE 7
Illustration by R. B. Birch for *Little Lord Fauntleroy*
by F. E. H. Burnett (1840–1924). First
published in 1886, the charming
manners and costume of the title
character became the model
for the small boys
of the time.

"I WAS THINKING HOW BEAUTIFUL YOU ARE," SAID LORD FAUNTLEROY.

He enshrined them in the drawing-room, on the first floor of his house and often occupying the whole of it. This was the throne room of the Lady of the House and the gilded cage of her daughters, whose "household duties" had now dwindled to a little dusting of the innumerable "knick-knacks" standing on the innumerable "what-nots". The names suggest that the resources of language had been exhausted by the profusion of trifles. It is odd to think that it is these trifles that we now like to collect.

Below the drawing-room was another large room – the dining-room. Large because the dining table was itself enormous and completely covered by the complicated set-out of a Victorian dinner; the epergnes, the candelabra, the silver, the cut-glass, the flowers – and the food itself which, at least until the last quarter of Victoria's reign, was all put on the table at once. Indeed we shall never understand a menu of the period until

PLATE 8
Loving-cup of about 1840 in transfer printed Staffordshire pottery, entitled "The Independent Order of Odd Fellows".

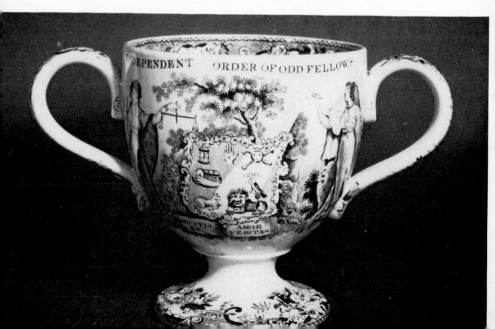

we realise that we are not looking at the time sequence of a meal but at the plan of a table.

On the second floor was the "front bedroom", occupied by the master and mistress of the house, and another, much smaller bedroom. The one or two floors above were shared by the servants and the children, furnished and decorated in a much more austere fashion although, paradoxically, it is from these rooms that come some of the most charming examples of Victoriana: the Staffordshire figures and the screens.

Of course there were many social levels even in the world of "above stairs". Gulfs yawned between Belgravia and Earl's Court, but the typical Englishman of the mid-century was a city merchant, with a house, bigger or smaller, nearer to Hyde Park Corner or more remote, but built to the same plan and harbouring the same kind of domestic set-up.

This was the kind of "home" that the poor dreamed of

PLATE 9

Papier-mâché face-screens, decorated with hand-painted scenes of Loch Leven and Loch Lomond, signed by Jennens and Betteridge.

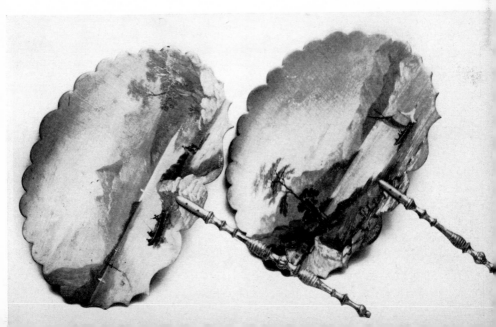

ART IN EXCELSIS.

THE MONTGOMERY SPIFFINSES HAVE JUST HAD THEIR DRAWING-ROOM CEILING ELABORATELY DECORATED BY ARTISTIC HANDS. THEY ARE MUCH GRATIFIED BY THE SENSATION PRODUCED UPON THEIR FRIENDS.

PLATE 10
Cartoon satirising the devotees of "Art" furnishings from *Punch* 1874, by George du Maurier (1834–1896), the gentle satirist of English family life, whose work also appeared in *Once a Week* and the *Cornhill Magazine*.

PLATE 11
Cartoon by S. Harrison for *Punch*, 1897, pointing the contrast between the extravagant fashions of the 'sixties and the long, slender lines of Art Nouveau.

Child's Picture-Book Fairy of '97 (to ditto of '67). "DEAR ME! WHAT A VERY SHOWY YOUNG PERSON!"

having and that prosperous men were proud to contemplate as the reward of their labours. Home, with a dignified and fruitful wife, dutiful sons, obedient daughters and domestics who, if individually tiresome, were, as a class, in plentiful supply. This was the shrine of domesticity dear to Victorian sentiment, and Englishmen liked to think that in no other country in the world could be found its like.

There was, indeed, much to be said for the typical Victorian home. It represented warmth and comfort and a shelter from the world. It was, or could be, the school of loyalty and comradeship, the academy of tact, the breeding ground of virtue, the abode of love. It was also, and long continued to be, a stronghold of liberty, for the front door was still unviolate and the requisitioning officer yet unheard of. It must have been very agreeable for the Tired Business Man (but perhaps business men were not tired until mechanical amusements began to be provided for their relaxation) to know that, at the end of his cab or omnibus ride from the City, his slippers were awaiting him, embroidered by the hand of wife or daughter, and carefully warming for him before the fire.

The rebellion against this happy state of affairs (happy perhaps only in retrospect) came from two sources: the Aesthetic Movement and the New Woman. The advent of both occurred in the 1880s and one has only to flick over the pages of *Punch* to realise the ridicule which both incited in the breast of the *bourgeoisie*. And not only ridicule but violent hostility, for both seemed threats to the established order – as indeed they were.

In "passionate Brompton" there were young women who wore loose Renaissance gowns and young men who grew their hair long and dressed like little Lord Fauntleroy. They went in for blue china and Japanese fans and "artistic" wallpaper. They despised the good academic pictures that pointed a moral or, at least, told a story. They were alleged to gaze at lilies in lieu of luncheon. The generic name for all their activities was Nincompoopiana.

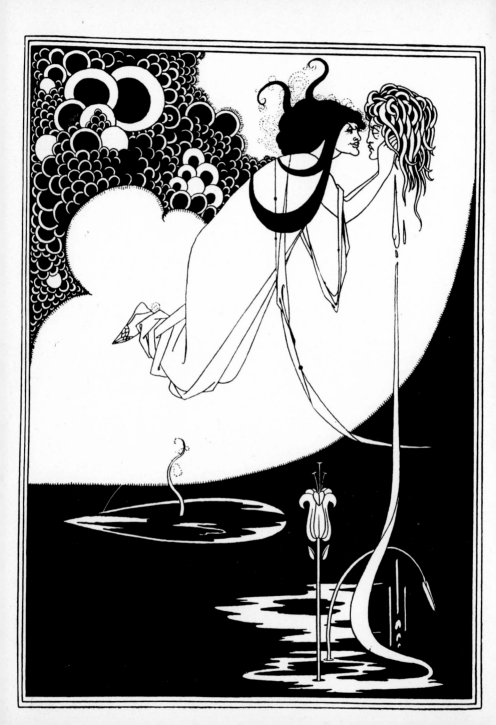

Irritating as they were to sensible philistines, they were not as alarming as the New Woman. The New Woman cherished many strange aspirations. She wanted to play cricket or even to "take up" nursing. Later, there was the bicycle, making the problem of marital and parental control ever more difficult. From Scandinavia came dark rumours of a "dramatist who encouraged women to escape from their 'doll's houses' and to live their own lives". There were some of the New Women who actually wanted the Vote.

Ordinary people were alarmed and not without reason. For what they were witnessing was the collapse of Victorianism; indeed, the beginning of the end of the Patriarchal System, for the emancipation of women is incompatible with many of the things that the nineteenth century held most sacred.

We know now that emancipation is a two-edged weapon, that when the middle class women emancipated themselves they were also emancipating the servant class, with the result that all women are now back at the kitchen sink. Perhaps it is our modern consciousness of this that feeds our nostalgia for the period of the great Queen's reign and which excites us to appreciate and so to collect Victoriana.

◀ **PLATE 12**
The illustrations by Aubrey Beardsley (1872–1898)
for Oscar Wilde's play-poem *Salome*, like those
for the *Morte d'Arthur* and *The Yellow Book*, seemed
to carry the revulsion of taste against the pretty
and the respectable to its ultimate extreme.
Beardsley's development of Burne-Jones's stylised
technique to convey undertones of vice and
depravity was condemned as decadent by the public.

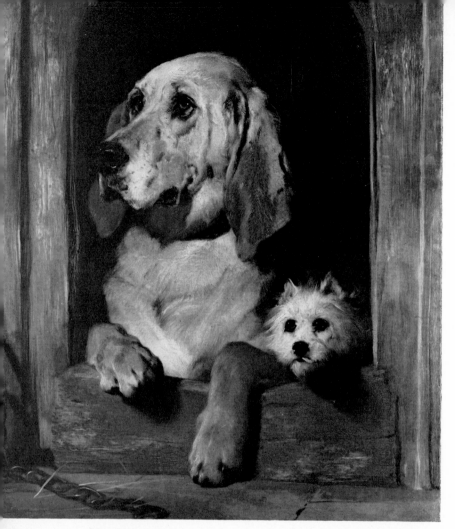

PLATE 13

Sir Edwin Landseer (1802–1873): *Dignity and Impudence*. A boy
prodigy who could etch, and draw in pencil, chalk and water-colour
by the age of ten, Landseer became most famous for his canine
burlesques of human life, and also for his Scottish scenes of
stags and shepherds' dogs. The sentimentality of his pictures
endeared him both to the public and to the Queen, whom he
instructed in etching, but not to the Pre-Raphaelites who despised
him for the lack of purpose and idealism in his art.

PAINTING AND SCULPTURE

It would be idle to deny that painting in England, throughout the greater part of the Victorian period, was curiously provincial; it did not belong to the main stream of European art. The pioneer work of Constable was ignored and even Turner was admired for the wrong reasons. The rising *bourgeoisie* might not know much about art but it "knew what it liked"; and what it liked were pictures with a story and, if possible a moral, and a good dose of sentiment always in danger of sliding off into sentimentality.

This explains the enormous popularity of a painter like Landseer. Landseer was a very competent painter, but his success was largely due to his choice of subject. Dogs were indeed irresistible, especially if they were mourning over their masters' coffins, and so were those sailors' widows or gamblers' wives who made the fortune of many a lesser artist. Even the Pre-Raphaelites, who were supposed to be breaking away from the Academic tradition, employed, when they were not wandering in an imaginary medieval world, exactly the same themes. What could be more of a moral anecdote than Holman Hunt's famous painting "The Awakening Conscience" or Rossetti's "Found"?

Some paintings were quite a novel in themselves and there was a flourishing industry in what was known as the "problem

picture". The whole art of it was to pose people – preferably two people – in attitudes, which implied that they were being torn by the most violent emotions, and yet to leave the precise emotion undefined. In a picture like "The Fallen Idol" no one quite knew whether the husband or the wife had "fallen". Perhaps, one felt, the story would be finished in the next instalment – or, rather, in the next exhibition at the Royal Academy. Augustus Egg did precisely that. His "Past and Present" series (showing the unfortunate results of a wife's infidelity) ran for three years.

Such pictures persisted with continued success to the very end of the century, but some artists, notably Frank Dicksee, (later Sir Frank Dicksee and President of the Royal Academy) followed a rather different line. He popularised the medieval fancies of the earlier Pre-Raphaelites, as in "La Belle Dame sans Merci" and "Harmony". Judged by the number of reproductions, the latter must have been one of the most popular pictures ever painted.

It was not necessary that the characters should be medieval. Marcus Stone specialised in a fancy dress version of the Directoire period (he made quite a corner in lovers' quarrels – "The Tiff" was a recurring title) and had an enormous success with it, even if it didn't bear much relation to the real clothes worn just after the French Revolution. Characters from Shakespeare's plays were dressed in every conceivable variety of pseudo-historical costume.

The artists who struck the best line of all were those who went to the Ancient World for their subject matter. This had a double advantage; it enabled them to adopt an attitude of the utmost respectability and culture and at the same time to fill acres of canvas with mildly provocative nudes. Alma-Tadema was rather timid about this. His Greek and Roman maidens are not very exciting; his real interest was painting marble, but some spirits were bolder and, for example, Edwin Long's "Babylonian Marriage Market" was, perhaps, the most (financially) successful English picture of the nineteenth century.

One of the most admired painters of the period (the darling, in fact, of the Aesthetes) was Burne-Jones. Inspired by Rossetti, but lacking his earthiness, he left the real world behind and wandered in the Celtic twilight of an enchanted wood where the sunlight never penetrated and the only sounds were the horns of elf-land lamenting the vanished chivalry of the Table Round.

We can only understand the violence of the reaction to Whistler's decorative "arrangements" and to Wilde's doctrine of "art for art's sake" if we realise that for the majority of Victorians there was something disturbing and even immoral in pictures which did not tell a story or point a moral. Today the Victorian pictures which have come back into favour are those in which the artist was content to depict the life of his times in meticulous detail. We may take as a prime example Frith's "Derby Day", which exacted Ruskin's disgust and Queen Victoria's admiration. In this at least she seems to us to have been the better critic.

PLATE 14 **William Dyce (1806–1864):** *The Woman of Samaria*. **His pictures produced the effect of a daguerrotype.**

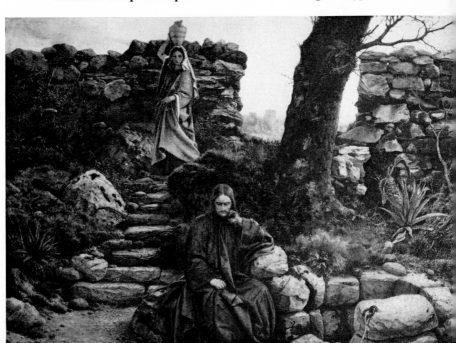

In sculpture England has nearly always lagged a little behind the Continent and the only two sculptors of international status in the Victorian period were Alfred Stevens and Alfred Gilbert. Both were in reaction against the neo-classicism which filled the art exhibitions with pale imitations of decadent Greek works. Stevens looked back to Michelangelo and Gilbert to the earlier Florentines. Both these men were perhaps more involved in the arts and crafts movement than they would have been if they had not rejected the Victorian distinction between the Fine Arts and the Applied Arts, and their influence in this sense was wholly to the good.

Lord Leighton and George F. Watts were sculptors as well as painters, and the latter was certainly the more vigorous and more concerned with purely plastic values. W. Hamo Thornycroft, Alfred Drury, Onslow Ford and George Frampton were the leading sculptors at the end of the century, but there is nothing particularly "Victorian" in their work. Indeed, there was no equivalent in sculpture for the work in painting of the Pre-Raphaelites. In any case sculpture for the Victorians was something to be seen in galleries or public parks. It was too bulky and too expensive for the home.

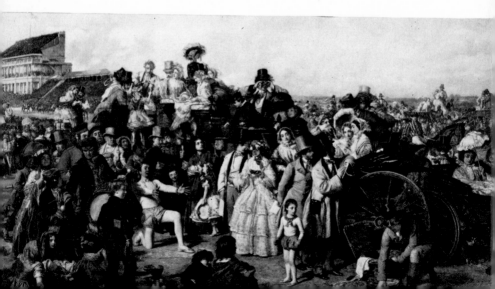

▶

PLATE 15
G. F. Watts (1817–1904): *Hope.*
Chiefly known for portraits of
his distinguished contempor-
aries, Watts also executed a
number of allegorical paintings
and "strange pictures of God
and Creation", taking as his
main themes the reality of the
power of love and the fallacy
underlying the fear of death.

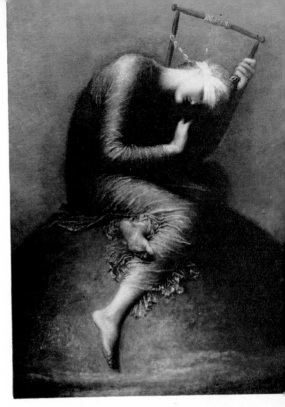

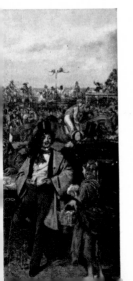

◀

PLATE 16
W. P. Frith (1817–1909): *Derby Day.* The wealthiest
artist of his time, Frith's best pictures were
his large and minutely detailed studies of
English contemporary life – *Ramsgate Sands, The
Railway Station*, and *Derby Day*. Though they
may not show great artistic originality, his
pictures do have tremendous period charm.

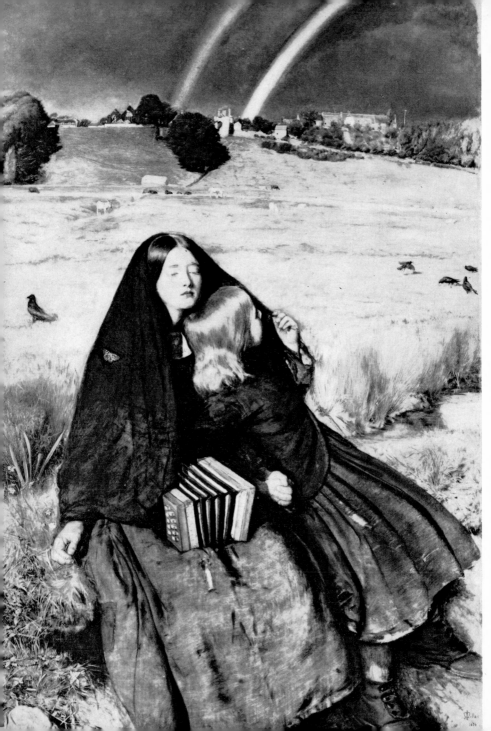

PLATE 17 William Holman Hunt
(1827–1910): *The Triumph of the
Innocents*. Hunt travelled to
Palestine in order to fulfil
the Pre-Raphaelite ideal of
"truth to nature" in his moral
and religious paintings.

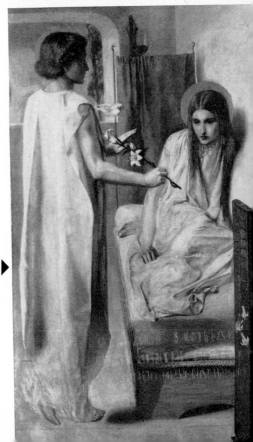

◀ PLATE 18 Sir John Millais (1829–
1896): *The Blind Girl*. Millais
painted a number of Pre-Raphael-
ite pictures in his early career,
but later found commonplace sub-
jects more profitable, and prints
of his pictures, like *Bubbles,*
were very popular.

PLATE 19 D. G. Rossetti (1828– ▶
1882): *The Annunciation*. Like
his relationship with the
beautiful, ailing Elizabeth
Siddal, Rossetti's characters
seem to struggle under a
mysterious, heavy-lidded sadness.

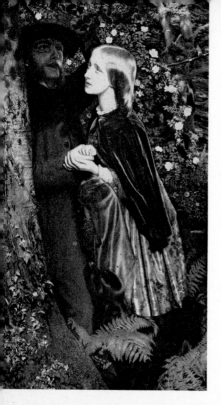

PLATE 20
Arthur Hughes (1832–1915): *The Long Engagement*. Hughes studied under Alfred Stevens, and was associated with William Morris in his early artistic enterprises. Faithful to the Pre-Raphaelite ideal, Hughes painted some of the most beautiful of the pictures done in this style, and was also widely known as a book illustrator.

PLATE 21
Henry Wallis (1830–1916): *The Death of Chatterton*. The only famous painting by this artist briefly inspired by the Pre-Raphaelite Brotherhood. ▼

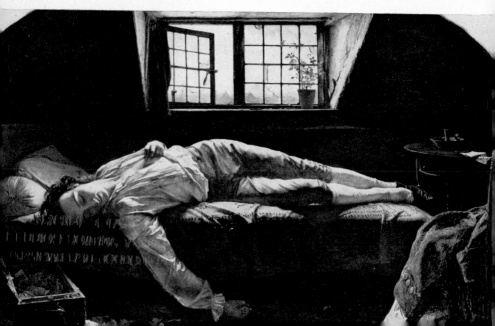

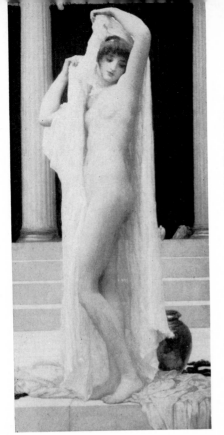

◀

PLATE 22
Frederick, Lord Leighton (1830–
1896): *The Bath of Psyche.*
Sculptor and painter, special-
ising in classical subjects,
Leighton did many paintings
which became best-sellers
in photogravure reproduction.

▶

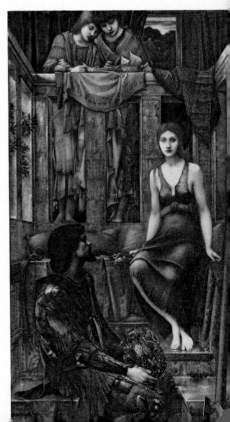

PLATE 23
Sir Edward Burne-Jones (1833–1898): *King
Cophetua and the Beggar Maid.* Encouraged
by Rossetti, Burne-Jones and William
Morris formed the nucleus of a revived
phase of Pre-Raphaelitism. Burne-Jones's
stylised version of earlier Pre-Raphaelite
art, which he peopled with pale, languid
figures, drew its inspiration from the
Arthurian romances and the Greek myths.

35

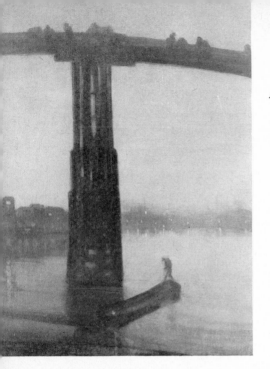

PLATE 24 ▶
Arthur Boyd Houghton (1836–1875):
The Volunteers. Though he had
the sight of one eye only,
Houghton was an excellent book
illustrator, and worked for *The
Graphic, Fun* and other magazines.
The bulk of his work was in black
and white, but he also executed a
number of oil paintings and was
known for his colourful
interpretation of Eastern subjects.

▲ PLATE 25
James Whistler (1834–1903): *Old Battersea Bridge – Nocturne in
Blue and Gold.* Influenced by the Impressionists, by blue and
white porcelain and by Japanese colour prints, Whistler developed
a style totally opposed to that of Victorian anecdotal painting
and the painstaking truth to nature of the Pre-Raphaelite
Brotherhood. He concentrated on the arrangement of tones and
the musical quality of colour, calling his pictures symphonies,
harmonies or nocturnes, thus inciting the displeasure of Ruskin
who accused him of "flinging a pot of paint in the public's face".

PLATE 26 ▶
Sir William Orchardson (1835–1910): *Her First Dance.*
Painted portraits and historical and social subjects.
His restrained designs and use of colour did not
at first appeal to the public, but after the exhibi-
tion of *On Board the "Bellerophon"* in 1881, he
enjoyed twelve years of great popularity.

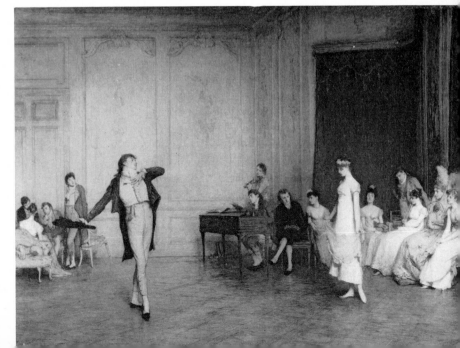

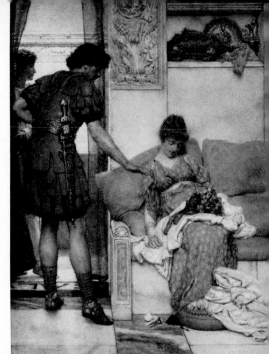

PLATE 27
Sir Lawrence Alma-Tadema (1836–1912): *A Silent Greeting*. His earlier paintings were anecdotal and the material drawn from medieval and Egyptian history. Later he turned to Greek and Roman history, and was especially adept at painting flowers, textures and hard reflecting surfaces.

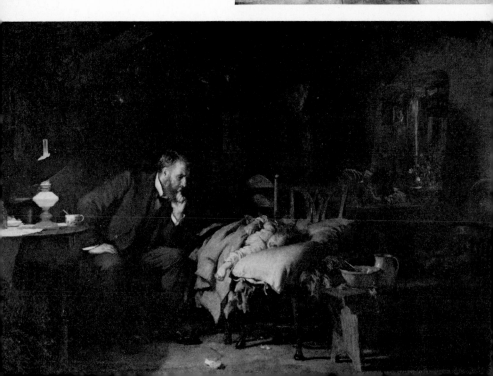

PLATE 28
Albert Moore (1841–1893): *The Dreamers.* **One of a family of
fourteen sons, three of whom became artists, Moore lived in a
world peopled with languid, hellenic figures and decorated with
brightly coloured draperies and flowers.**

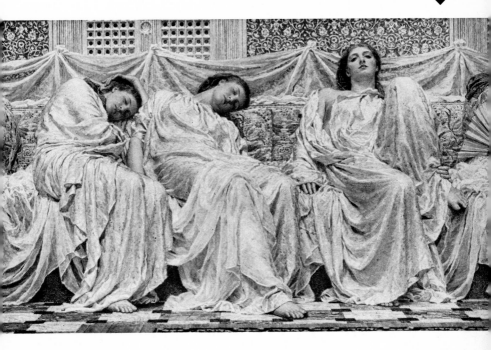

PLATE 29
Sir Luke Fildes (1844–1927): *The Doctor.* **All Fildes's pictures
had a pathetic interest, like this his best known work. Later in
his life he turned to portrait painting, and was well known as a
woodcut designer for the magazines and for his illustrations to
Dickens's** *Edwin Drood.*

PLATE 30 ▶
J. W. Waterhouse (1849–1917): *The Lady of Shalott*. In his early career, Waterhouse dealt with allegorical and classical subjects. But later, influenced by the "Plein Air" painters, he aimed at combining their vibrating atmospheric qualities with the decorative design and romantic subject-matter of Burne-Jones.

PLATE 31
Sir Frank Dicksee (1853–1928): *Harmony*. Romantic and sentimental, Dicksee was very much a painter of his time, expressing poetic sentiments in pictorial form. There were popular reproductions ▼ of many of his historical subject paintings.

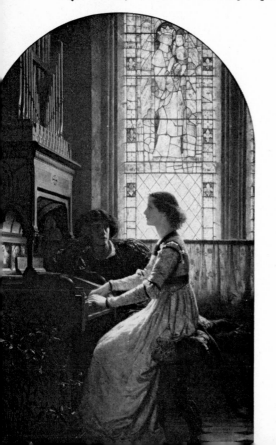

PLATE 32 ▶
Sir Hubert von Herkomer (1849–1914): *Found*. A man of broad-ranging interests, Herkomer employed a great variety of artistic mediums, as well as being a journalist, composer, singer and actor. Besides his oil-painting, he achieved success as a worker in enamel, an etcher, a mezzotint engraver, and, influenced by Fred Walker, as an illustrator.

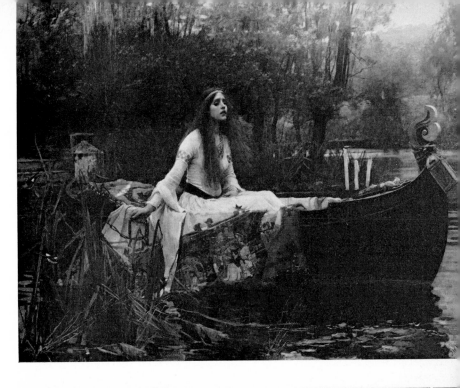

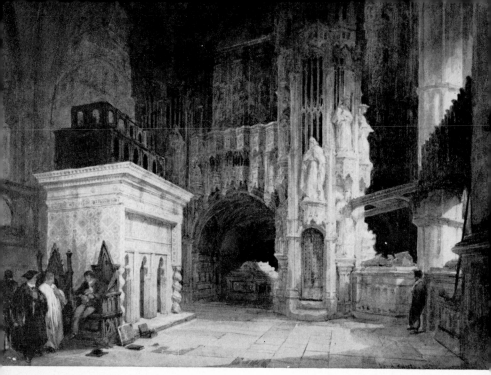

PLATE 33 David Roberts (1796–1864): *The Shrine of Edward the Confessor*. Water-colour. Starting as a house-painter, Roberts turned to architectural painting with his *Rouen Cathedral* in 1826, and later drew on material collected on his travels.

PLATE 34 George Cattermole (1800–1868): *A Castle Entrance*. Water-colour on brown paper. At first a purely architectural painter, he later included historical incidents and especially scenes from Shakespeare's plays.

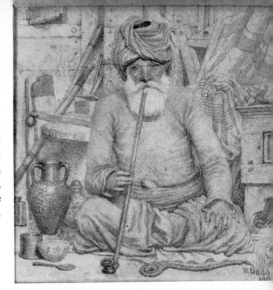

PLATE 35 Richard Dadd (1817–1887): *A Turk*. Water-colour. While painting water-colours in the East in 1842, Dadd's mind was affected by sunstroke and he later murdered his father, but he continued to paint while confined in hospital.

PLATE 36
William Callow (1812–1908): *Richmond Castle, Yorkshire*. Water-colour on tinted paper. His water-colour *View from Richmond* led to his engagement as drawing master in the family of Louis-Philippe, but after 1841 he settled permanently in England except for occasional sketching tours on the Continent.

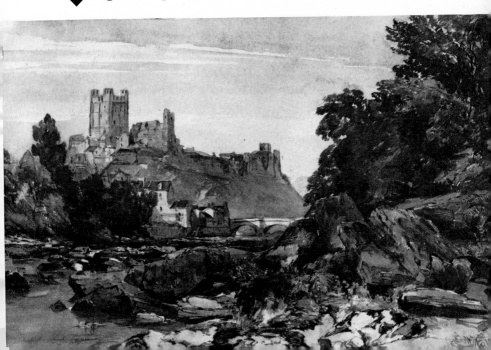

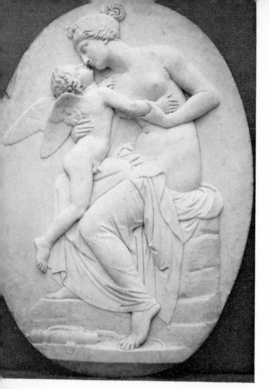

◀

PLATE 37
John Gibson (1790–1866): *Venus and Cupid*. **Marble. Gibson studied under Canova and Thorvaldsen in Rome and lived there permanently. He executed a number of works in the round, notably of *Queen Victoria Supported by Justice and Clemancy*, but also excelled in *basso rilievo*. He was the first Englishman to introduce colour on his statues.**

PLATE 38 Sir George Gilbert Scott (1811–1878): Frieze from the Albert Memorial, the whole designed by Scott, and decorated by a number of prominent Victorian sculptors. ▼

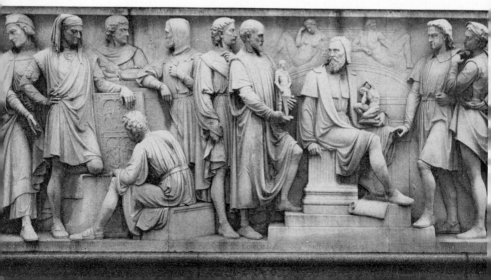

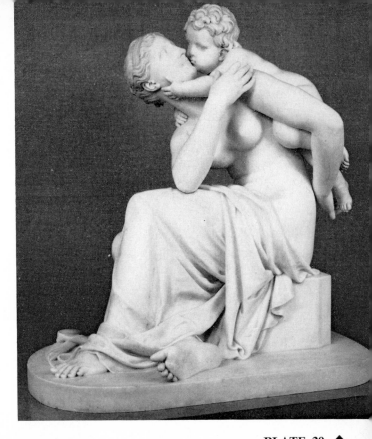

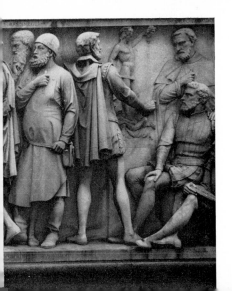

PLATE 39 ▲
Edward Hodges Baily (1788–1867):
Maternal Affection. Marble.
Baily executed many of the well-
known London statues, including
that of Lord Nelson in Trafalgar
Square, and the bas relief on the
south side of Marble Arch.

45

PLATE 40 Alfred Stevens (1817–1875): *Valour and Cowardice*,
plaster casts of the allegorical groups on the competition model
for the Wellington Monument of 1857. Appointed teacher of
architectural design at Somerset House, Stevens designed furniture,
fireplaces and porcelain as well as sculpture, but the chief work
▼ of his life was the Wellington Monument for St. Paul's Cathedral.

PLATE 41 E. B. Stephens (1815–1882): *The Bathers*. A pupil of
Baily's, Stephens assisted in the decoration of the Summer
Pavilion at Buckingham Palace, and made a fine group in bronze
of *The Deerstalker* exhibited at the Royal Academy in 1876. ▼

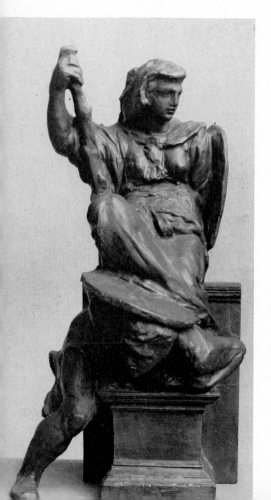

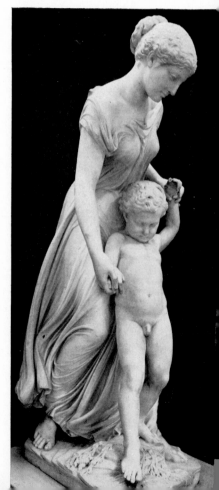

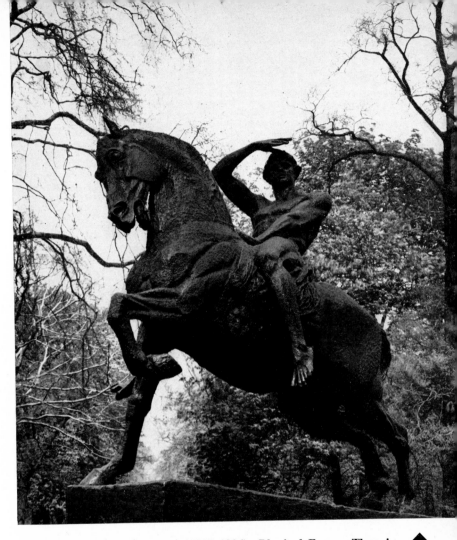

PLATE 42 G. F. Watts (1817–1904): *Physical Energy*. **There is a ▲
sculpturesque quality to many of Watts's paintings, but he
executed comparatively few sculptures.** *Physical Energy,*
**originally intended for a place on the Embankment, was set up as
a monument to Cecil Rhodes on the Matoppo Hills. There is
a replica in Kensington Gardens.**

47

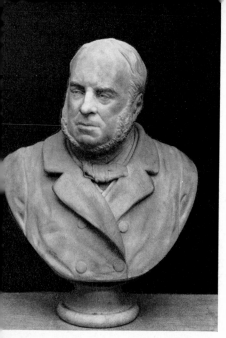

PLATE 43 Sir Joseph Boehm
(1834–1890): *Mr. Wynn Ellis*.
Marble. Among his most
important statues is that of
Queen Victoria for Windsor
Castle, the equestrian statue
of the Duke of Wellington,
and the monument to General
Gordon in St. Paul's Cathedral.

PLATE 44 E. O. Ford (1852–
1901): *Folly*. Bronze. The first
work cast by the *cire perdue*
process in this country during
recent times. Small replicas
were cast of many of his bronzes.

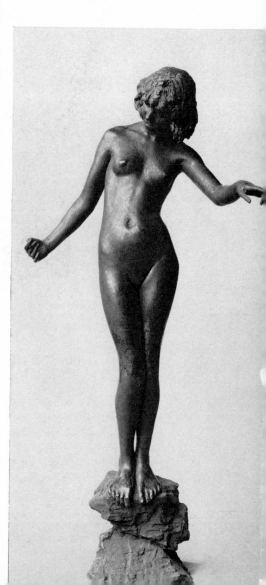

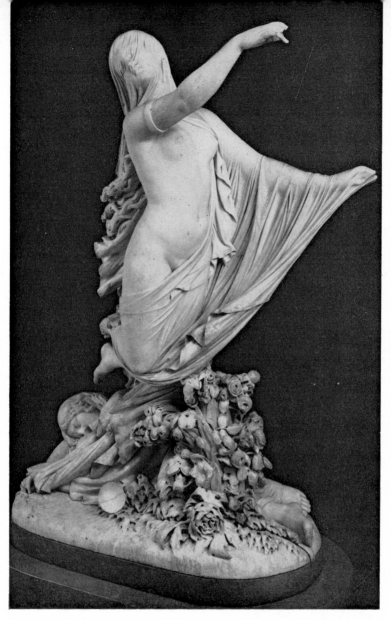

PLATE 45 Raffaelle Monti (1818–1881):
Marble. *The Sleep of Sorrow and a
Dream of Joy*. An allegory of the
Italian Risorgimento.

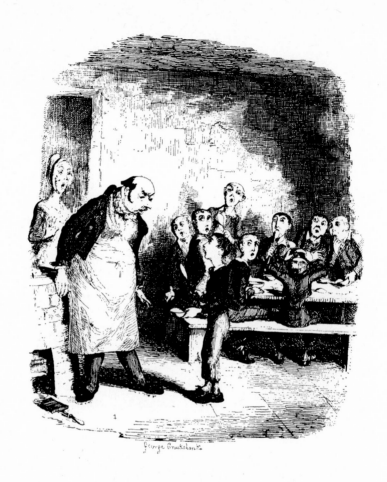

Oliver asking for more

**PLATE 46 George Cruikshank (1792–1878): From his
illustrations to Dickens's *Oliver Twist*. Cruikshank
did both etching, when he worked on the copper plates
himself, and wood engraving. Among the many books
he illustrated are Scott's *Guy Mannering*, Dickens's
Sketches by Boz, and Thackeray's *Legend of the Rhine*.**

BOOKS

The nineteenth century was a great age for the illustrated book. Typical of the early years of the Queen's reign were those innumerable "albums" and "keepsakes" to be found on the drawing-room tables of so many homes. Many of the plates were "after J. M. W. Turner" and were in line-engraving. This process was finally defeated by its own technical perfection and the use of mechanical ruling devices to give tone, and was superseded by a revival of engraving on wood. England for the most part failed to share in the great burst of lithography which gave France a Daumier and a Gavarni and, when the great era of illustrated magazines began in 1842 with the founding of the *Illustrated London News*, the chosen medium was wood-engraving.

Moxon's publication, in 1857, of an edition of Tennyson's *Poems*, entirely illustrated with wood-engravings, was a revelation of the possibilities of this medium when the draughtsman was of high rank and the engraver a conscientious craftsman. The artist drew direct upon the wood-block and the wood-block was of a better quality than it had ever been before, for it was composed of small pieces of the hardest boxwood screwed together and presenting their cross-section to the engraver's tool.

"The Illustrators of the 'Sixties" has become a recognised phrase of the art historian. Even the names of the engravers – Swan, Hooper, Linton and the Dalziels – are known to all who

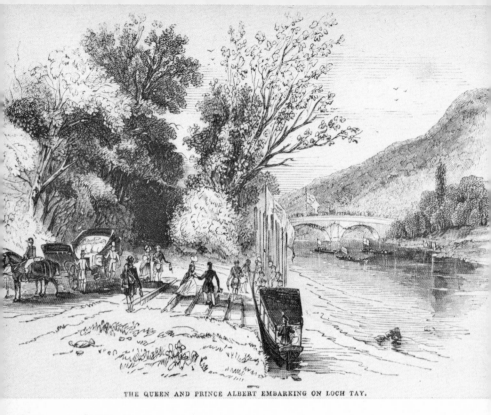

THE QUEEN AND PRINCE ALBERT EMBARKING ON LOCH TAY.

PLATE 47
Wood engraving illustrating the Queen's tour of
Scotland, from *The Illustrated London News*, 1842.

are interested in the matter; and among the draughtsmen we
have Millais, Rossetti, Holman Hunt and all the Pre-Raphaelite
Brotherhood, as well as Whistler, Arthur Boyd Houghton,
Frederick Walker, Pinwell, Charles Keene, John Gilbert and
Frederick Shields. These men all contributed to a real revival of
the art of the book, a specifically English accomplishment, for
there is nothing quite like it anywhere on the Continent of
Europe.

Reinforced by Tenniel, Burne-Jones, George du Maurier,

52

Leighton, Simeon Solomon and others, they carried the art of illustration to its highest pitch within the limits of their chosen medium. And Burne-Jones, under the influence of William Morris, began an attempt to relate the illustration to the printed page in a way that only Blake and some of the earliest Italian illustrators had succeeded in doing. Morris's great Kelmscott Press edition of the works of Chaucer, illustrated by Burne-Jones, is a monument which, for all its wilful medievalism, remains to inspire future generations with the force of an ideal.

It is curious that some of the best illustrated books of the period were designed for children. Tenniel's famous illustrations for *Alice's Adventures in Wonderland* appeared in 1865 in the very middle of the great decade of wood-engraving, but other children's illustrators were shortly to find other processes available. Edmund Evans perfected a method of colour printing in outline and flat washes which made possible the work of Randolph Caldecott, Kate Greenaway and Walter Crane. Kate Greenaway's charming children, dressed in a romantic costume of no particular period, were deservedly popular, and Ruskin himself hailed them as works of genius. Caldecott, who had previously worked for *Punch* and for Christmas Supplements, made an agreement with Edmund Evans in 1878 to illustrate a series of children's books. His clear outlines, his gay but simplified colour and his strong sense of the unity of the decorative page were perfectly adapted to the new medium. He preferred, in general, to illustrate simple themes, sometimes mere nursery rhymes. If the rhymes had something to do with horses and hunting so much the better. *John Gilpin* was published in the first year of his new enterprise and was quickly followed by *Three Jovial Huntsmen*. His *Ride a Cock Horse to Banbury Cross* came out two years before his death. Walter Crane's range as an artist was much wider, but he produced in his early years such charming toy-books as *The Three Bears* and *Mother Hubbard*. Mention should also be made of "Dicky" Doyle's delightful illustrations for William Allingham's poem *In Fairyland*.

The increasing use of photography not only made it possible to reproduce a line-drawing without destroying the original, but began to modify, sometimes unfortunately, the whole technique of the illustrator. A drawing by Phil May might conceivably have been reproduced – or translated – by the methods of "the Sixties", a drawing by Aubrey Beardsley could not. But Beardsley's balance of black and white masses lent itself admirably to reproduction by mechanical means and so made possible his illustrations for Oscar Wilde's *Salome* and Pope's *Rape of the Lock*. These, with the more derivative work of Ricketts and Shannon for *The Dial* and the Vale Press bring us to the end of the nineteenth century.

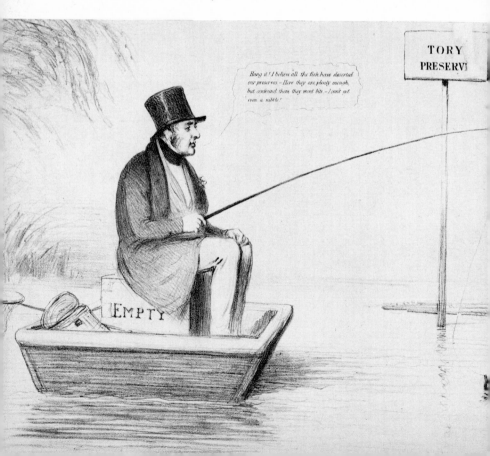

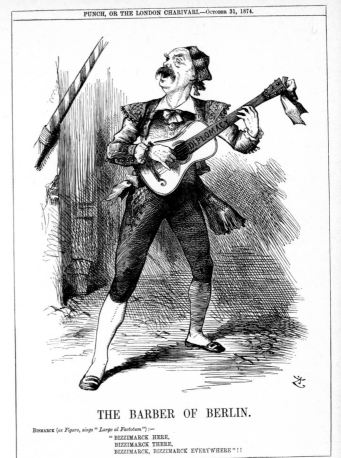

THE BARBER OF BERLIN.

Bismarck (*as Figaro, sings "Largo al Factotum"*):—
"BIZZIMARCK HERE,
BIZZIMARCK THERE,
BIZZIMARCK, BIZZIMARCK EVERYWHERE"!!

PLATE 48 Sir John Tenniel (1820–1914): Cartoon ▲
of Bismarck, from *Punch*, 1874. Tenniel joined the
staff of Punch in 1851, succeeded Leech as chief
cartoonist in 1864, and drew more than 2,000
cartoons during the next fifty years.

◄
PLATE 49 John Doyle (1797–1868), known as H. B.
Cartoon inspired by Peel's lively description of
the Whig Chancellor of the Exchequer "seated on
an empty chest, by a pool of bottomless deficiencies,
fishing for a budget". H. B.s political sketches
took London by storm in the early 1840s.

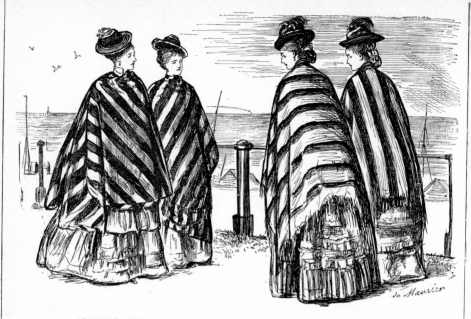

WOMEN AND THEIR GARMENTS ARTISTICALLY DESCRIBED.

STUDY OF A HORIZONTAL ARRANGEMENT IN TONED WHITE, PURPLE, AND BROWN, ACCOMPANIED BY A VERTICAL SYMPHONY IN ORANGE, BLUE, AND CRIMSON, MEETING A DIAGONAL DUETT IN BLACK AND YELLOW.

"MELANCHOLY, SLOW."

Conductor. "LOOK ALIVE, BILL! HERE'S A OLD GENT INSIDE'S AFRAID HE WON'T KETCH HIS FUNERAL!"

PLATES 50 & 51
Cartoon from *Punch*, 1874, satirising the style and titles of Whistler's paintings, by George du Maurier (1834–1896). Du Maurier, who joined *Punch* in 1865, was a subtle cartoonist in a romantic style, while Charles Keene (1823–1891) "sang the comic songs" for the magazine, as in this cartoon of 1874. Many of Keene's best cartoons were inspired by the stories of the painter Joseph Crawhall.

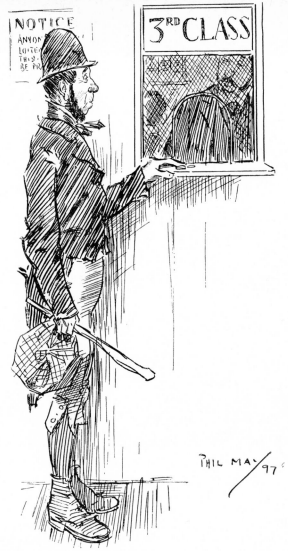

Clerk. "RETURN?"
Pat. "PHWAT FOR 'UD OI BE WANTIN' A RETURRN TICKUT WHEN OI'M HERE ALREADY?"

PLATE 52
Phil May (1864–1903): Cartoon from *Punch*, 1897. Already well-known for his work on the *St. Stephen's Review*, May joined the staff of *Punch* in 1896. His studies of the London "guttersnipe" and the coster-girl are drawn with sympathy, wit and an amazing economy of line.

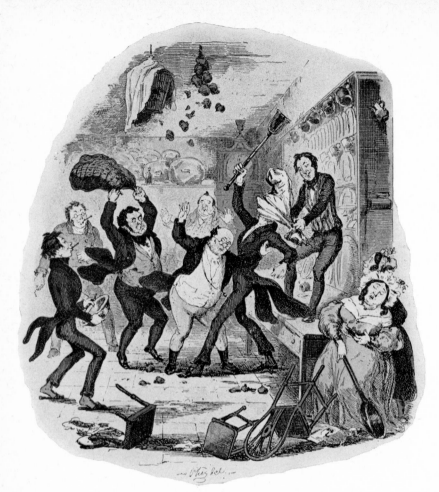

▲ PLATE 53 H. K. Browne (1815–1882) known as Phiz: *The Rival Editors*,
an illustration for Dickens's *Pickwick Papers*. Originally a line
engraver, but later taking to etching and water-colour painting,
Phiz also illustrated many of Dickens's novels, as well as the
best known novels of Lever and Ainsworth.

PLATE 54 John Leech (1817–1864): Engraving for *The Comic History* ▶
of Rome. Leech contributed woodcuts to *Once a Week* and the
Illustrated London News, and etchings for *Bentley's Miscellany*
and *Jerrold's Magazine* as well as his cartoons for *Punch*.

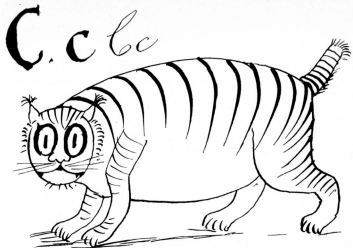

C was a lovely Pussy Cat; its eyes were large & pale;
And on its back it had some stripes,
and several on his tail.

PLATE 55 Edward Lear (1812–1888): *A Nonsense Alphabet*. Lear ▲
painted landscapes in Italy, Egypt and Greece, and produced
illustrated books of his travels, but he is best known today
for his *Book of Nonsense* and other books in this vein.

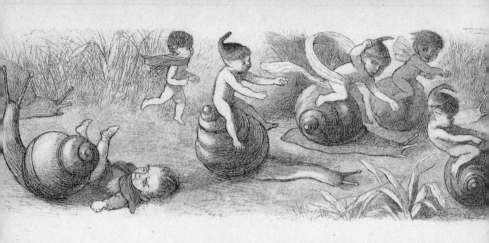

Amongst the sports and pastimes of the Little People, there was

upon a time, a great race of all the swiftest snails in Fairyland.

PLATE 56 Richard Doyle (1824–1883): From *In Fairyland*, engraved ▲
by Edmund Evans. Doyle's father, H. B., gave him his only
training, but he was an extremely gifted amateur, had a very
fanciful imagination and a keen sense of the grotesque. He
worked on *Punch* until 1850, and subsequently illustrated books
and painted water-colours.

◄ PLATES 57 & 58 Sir John Tenniel
(1820–1914): From *Alice in Wonder-
land*, engraved by the Brothers
Dalziel, to whom credit is as much
due for the fineness of the end-
product as to the artist. Tenniel
contributed illustrations to
*Aesop's Fables, Punch, Once a
Week* and others, as well as to
both of Carroll's books.

◀

PLATE 59 G. J. Pinwell (1842–1875): *The Dovecote.* **Woodcut for** *English Rustic Pictures,* **1865. Pinwell worked for** *Fun* **and** *Once a Week,* **and illustrated Goldsmith, Jean Ingelow's** *Poems* **and the** *Arabian Nights.* **His style of water-colour painting derived from his drawings on the wood, and is characterised by pure, bright colour and an opalescent effect.**

PLATE 60 From the *"Kelmscott" Chaucer,* **finished in 1896. The** ▶ **book was the crowning glory of Morris's Kelmscott Press, illustrated with woodcuts after drawings by Burne-Jones. Typically, Morris had to rethink the whole process of book production before he began on the work itself, designing his own type and using for paper the purest linen rag.**

Incipit secunda pars ✤ ✤ ✤ ✤

FER FRO THILKE PALAYS HONUR-
ABLE
Theras this markys shoop his mariage,
Ther stood a throop, of site delitable,
In which that povre folk of that village
Hadden hir beestes and hir herbergage,
And of hire labour tooke hir sustenance,
After that the erthe yaf hem habundance.

AMONGES thise povre folk ther
dwelte a man
Which that was holden povrest of
hem alle;
But hye God som tyme senden kan
His grace into a litel oxes stalle:
Janicula men of that throop hym calle.
A doghter hadde he, fair ynogh to sighte,
And Grisildis this yonge mayden highte.

But for to speke of vertuous beautee,
Thanne was she oon the faireste under sonne;
For povreliche yfostred up was she,
No likerous lust was thurgh hire herte yronne;
Wel ofter of the welle than of the tonne
She drank, and for she wolde vertu plese,
She knew wel labour, but noon ydel ese.

But thogh this mayde tendre were of age,
Yet in the brest of hire virginitee
Ther was enclosed rype and sad corage,
And in greet reverence and charitee
Hir olde povre fader fostred shee;
A fewe sheep, spynnynge, on feeld she kepte,
She wolde noght been ydel til she slepte.

And whan she homward cam, she wolde brynge
Wortes, or other herbes, tymes ofte,

▲ PLATE 61 Walter Crane (1845–1915): Illustrations from *A Flower Wedding*. Crane decorated rooms, china and furniture, illustrated *The Story of the Glittering Plain* by Morris, as well as Spenser's *Faerie Queen* and some poems of his own, but chiefly worked on children's books.

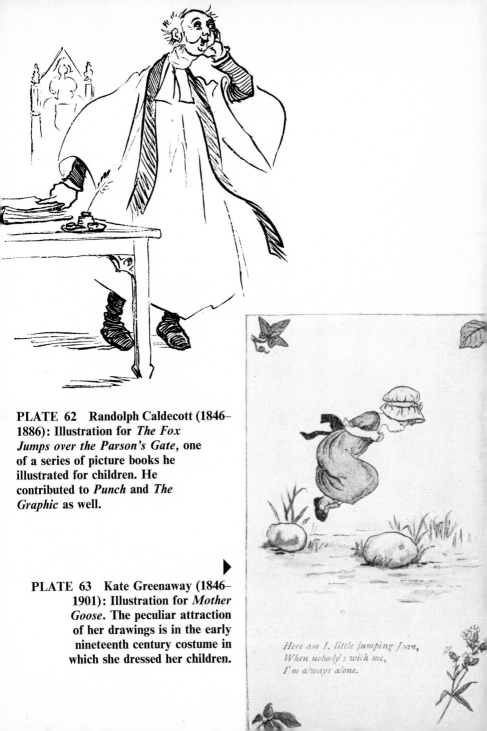

PLATE 62 Randolph Caldecott (1846–1886): Illustration for *The Fox Jumps over the Parson's Gate,* one of a series of picture books he illustrated for children. He contributed to *Punch* and *The Graphic* as well.

PLATE 63 Kate Greenaway (1846–1901): Illustration for *Mother Goose.* The peculiar attraction of her drawings is in the early nineteenth century costume in which she dressed her children.

Here am I, little jumping Joan,
When nobody's with me,
I'm always alone.

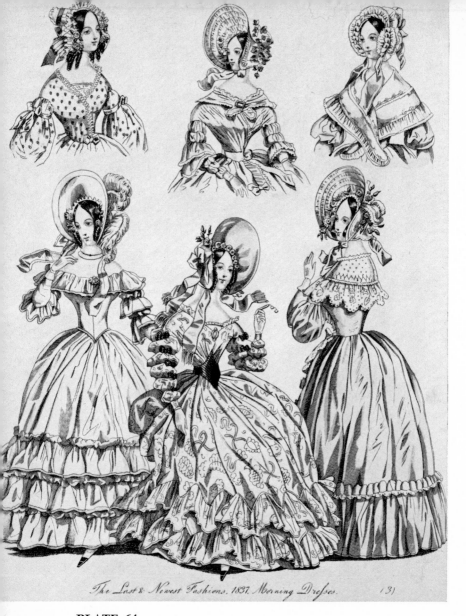

The Last & Newest Fashions. 1837. Morning Dresses. (3)

PLATE 64
Fashion plate from *The World of Fashion*, 1837. As the growing
middle class had more money to spend on clothing, the fashion
magazines, with their copies of French fashion plates, were
eagerly snapped up.

FASHION AND
FASHION PLATES

The fashion plate is almost exclusively a nineteenth century product and, naturally, the greatest number were issued during Queen Victoria's reign. There had been *costume* plates before (as early as the sixteenth century), but these showed the clothes worn in the past. The fashion plate is essentially a thing of the present – or even the future – and it hardly existed before the French Revolution when ladies' magazines made their sudden appearance. These were adorned with etchings or line-engravings coloured by hand (the lithographic process being added later) and their progeny multiplied until about 1900, when they were replaced by mechanical reproductions which have none of the charm of the genuine article.

England played an important rôle in the early development of the fashion plate, the *Gallery of Fashion* issued in the seventeen-nineties being at least equal to anything of the kind produced in France. The *Ladies' Monthly Magazine*, which first appeared in 1798, was soon followed by *Le Beau Monde* and *La Belle Assemblée*, both these journals being, in spite of their French titles, published in London. However, France soon caught up and had obtained such a dominating position by the middle of the century that most of the English fashion magazines gave up trying to produce their own plates or even to copy those from across the Channel. They contented themselves with importing French

plates from such papers as *Le Follet* and *Le Moniteur de la Mode*, sometimes not even troubling to re-engrave the titles. It is therefore a matter of indifference to the collector whether the plates were actually issued in France or in England.

The period from about 1840 to 1870 has been called the Golden Age of the fashion plate. The principal artists were F. C. Compte-Calix, Janet Lange, the mysterious "Numa", and the three clever daughters of Alexandre Marie Colin, who became, respectively, Héloïse Leloir, Anaïs Toudouze and Laure Noël. Ladies with such "sweet symphonies" of names could hardly fail to produce works of distinction and charm, and anyone who wishes to collect fashion plates would do well to keep his eyes open for their signatures, which can often be found scrawled inconspicuously on the corner of the plate, half hidden by the arabesques of the design.

The great charm and interest of their plates, and of nearly all the fashion plates of the period is that, whereas single figures had formerly been considered sufficient, now the designers began to depict whole groups with appropriate backgrounds. The result is a series of glimpses of life as it was lived by the upper classes. There are seaside scenes and racecourse scenes, and interiors: drawing-rooms, ballrooms and conservatories from which much can be learned of the taste of the time in furniture and decoration. We see the doll-like inhabitants of this paradise of "gracious living" (a phrase the nineteenth century would probably have found incomprehensible) seated at the piano or playing the harp, or displayed like a Victorian nosegay in a box at the opera. We watch them playing with their children and occasionally – only occasionally – conversing with their husbands, who are usually either in evening dress or accoutred for the chase. Sometimes the designers pluck up courage to show women in their underclothes, thus providing a valuable footnote to costume history.

The English magazines had become so dependent upon French sources that, when the supply was cut off by the Franco-Prussian

War of 1870, they had to make do with some very inferior productions. However, France quickly recovered and soon the importation of French fashion plates was once more in full swing and some splendid examples were produced in the last quarter of the century, before the true fashion plate came to an end.

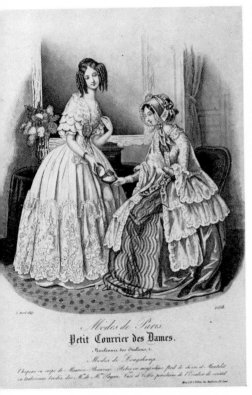

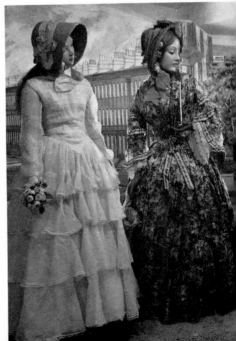

PLATE 65 Unsigned fashion plate of 1847 from *Le Petit Courier des Dames* (1822–1865), showing the fashionable corkscrew curls of that decade. The plates for this magazine were usually left unsigned, but most were designed by A. Pauquet, E. Préval, A. de Taverne, Laure Noël and Hervy.

◀

PLATE 66 Ladies in Pulteney Street, Bath, dressed in the fashions of the 1840s and early 1850s. The clothes could be dated from the poke bonnet alone.

▶

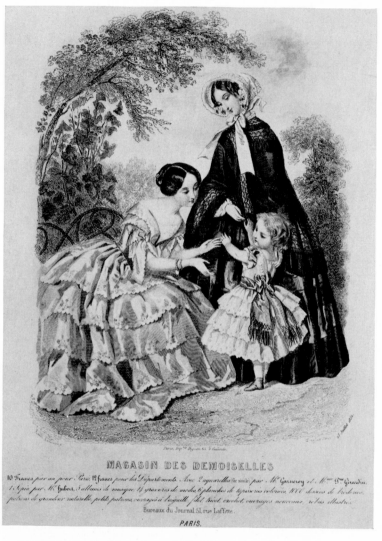

MAGASIN DES DEMOISELLES

10 Francs par an pour Paris, 12 francs pour les Départements. Avec 2 aquarelles (en suite) par Mᵐᵉ Garnerey et Mᵐᵉ Dⁿᵉ Girardin. 1 copie par Mᵐᵉ Hubert, 3 albums de musique, 14 gravures de modes, 8 planches de tapisserie coloriées, N°C. dessins de broderies, patrons de grandeur naturelle, petits patrons, ouvrages à l'aiguille, filet, tricot, crochet, ouvrages nouveaux, 10 bas illustrés.

Bureaux du Journal, 51, rue Laffitte.

PARIS.

PLATE 67 Fashion plate of 1852 from *Le Magasin des Demoiselles* (1844–1893) by Anaïs Toudouze (1822–1899), a prolific artist of the later Victorian period, whose models were placed on delicately drawn backgrounds.

PLATE 68 Parlour scene in the 1850s, the father dressed
in a fashionable smoking cap and slippers in Berlin wool.
Ladies' skirts continued to expand throughout the 1850s,
aided from 1856 by factory-made steel-hooped petticoats.

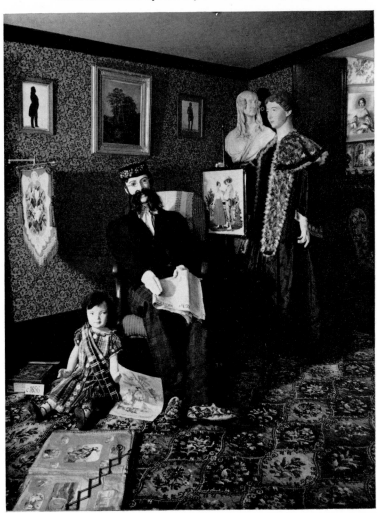

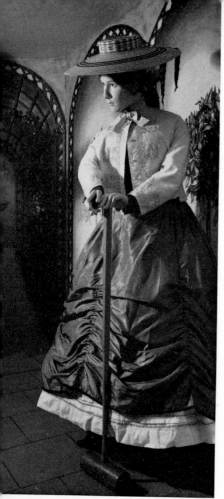

PLATE 69 Fashion plate of 1865 from *The Englishwoman's Domestic Magazine* (1852–1877) by Jules David (1808–1892). Jules David designed all the plates for *Le Moniteur de la Mode* between 1843 and 1892, and these were reproduced in fashion magazines in both England and Germany. *The Englishwoman's Domestic Magazine* is also notable in that it was the periodical in which Mrs. Beeton's *Household Management* first appeared in serial form.

▼

▲ PLATE 70 Scene in a Conservatory of the 1860s. The girl is wearing a croquet dress, the ample skirts festooned up over a fancy petticoat.

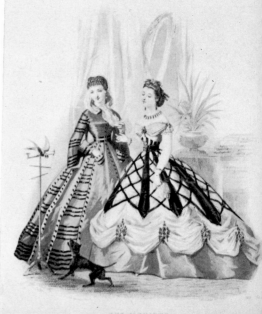

PLATE 71 Fashion plate of 1871 from an
Italian version of *Les Modes Paris-*
iennes (1843–1875) by François-Claudins
Compte-Calix (1813–1880). Compte-Calix,
who also illustrated books and painted,
drew pretty, graceful, rather sentimen-
tal models, and used beautiful colour
on his plates. Skirts had reached their
maximum point of expansion during the
1860s, and now were reduced again
to a more manageable size.

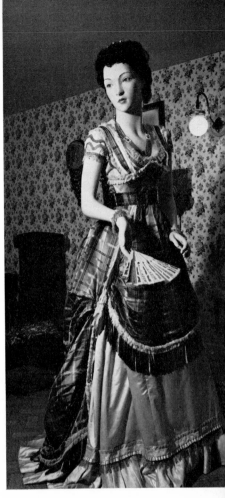

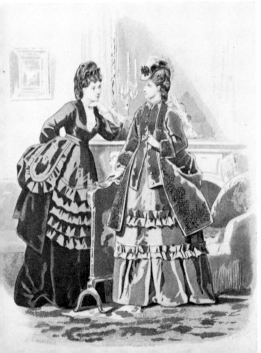

PLATE 72 Dress in a
French version of tartan
made for Queen Alexandra
when Princess of Wales,
about 1873, by a French
dressmaker named Élise.

PLATE 73 Fashion plate of 1881 from an Italian version of the Berlin magazine *Der Bazar* (founded in 1854) by Jules David. E. Préval also contributed to the magazine, which, like the English ones, borrowed French plates.

PLATE 74 Scene in a sitting-room of the 1880s. The dresses have become elongated and closely fitting, and the ladies have frizzed their hair. Clearly they disapprove of the Dress Reform movement and William Morris.

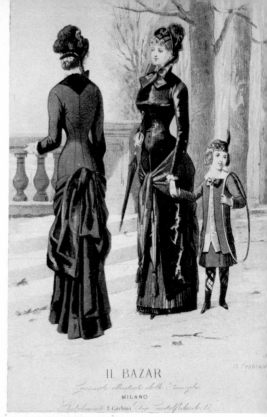

IL BAZAR
Giornale illustrato delle Famiglie
MILANO

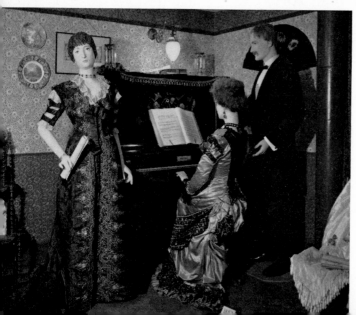

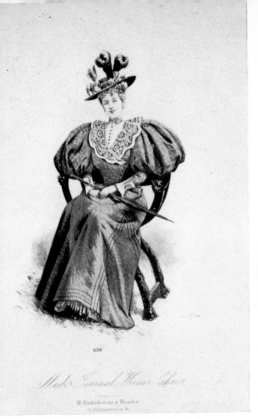

PLATE 75 Unsigned fashion plate of about 1894 from the Viennese magazine *Wiener Chic*, founded in 1891. Characteristic of the 1890s were the large balloon or gigot sleeves, the small waist and the wide, stiff skirt. In this plate the background has once again become unimportant to the artist, who has concentrated his attention exclusively on the clothes themselves.

PLATE 76 Day clothes of the 1890s, reflecting, to some extent, the new freedom among women.

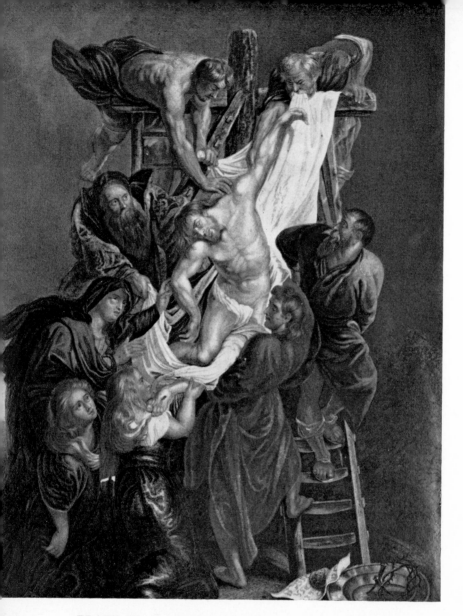

PLATE 77 *Descent from the Cross,* a print in oil colours by George Baxter (1804–1867) from the painting by Rubens. One of Baxter's greatest successes, in which he achieved brilliant colours and warm flesh tints on the living bodies. A plate and fourteen blocks were required to process the print.

BAXTER AND OTHER PRINTS

In the early years of the century the favourite prints for collectors were the political coloured etchings produced by men like Gillray and the elder Cruikshank, but in Early Victorian days these had largely been rendered obsolete by the rise of illustrated magazines. Connoisseurs began to be aware of what is called the revival of etching, which was to reach its apogee in the work of Whistler and Seymour Haden. But the most typical graphic production of the first half of the Queen's reign was undoubtedly the Baxter print.

George Baxter's object was the imitation of oil paintings by mechanical means. His method was to impose on a print from an engraved metal plate a series of wood blocks each impregnated with a different colour. He printed his first few subjects in water ink but then began to use oil ink, and it is this (which he claimed as his patent) which gives Baxter prints their characteristic quality.

What gives them their attraction for the modern collector is his choice of subjects. At the time of the Queen's accession these were mostly of landscape and what were known as "missionary subjects", but we soon find such titles as "The Baptism of the Prince of Wales" and a whole series of Royal portraits. With the Great Exhibition of 1851 Baxter really came into his own. Some of his most ambitious efforts show every

aspect of the Crystal Palace in Hyde Park, and his smaller "Gems of the Great Exhibition", some of them on mounts with a gold border, were extremely popular, as was also his "Funeral of the late Duke of Wellington". Baxter also produced large numbers of prints of flowers, children and genre subjects derived from the more sentimental painters of the period.

Baxter's method was soon to be challenged by chromo-lithography and this process was particularly successful in reproducing the newly fashionable early Florentines, whose frescoes and other paintings had nothing of the oily look at which Baxter aimed. Baxter prints, however, remain to us as examples of Victoriana as completely redolent of their epoch as wax fruit.

PLATE 78 Baxter print of the *Crystal Palace and gardens at Sydenham* in 1854, showing the fountains, the grounds and the antediluvian animals designed by Waterhouse Hawkins and set up in the same year. Hawkins also did the original drawing.

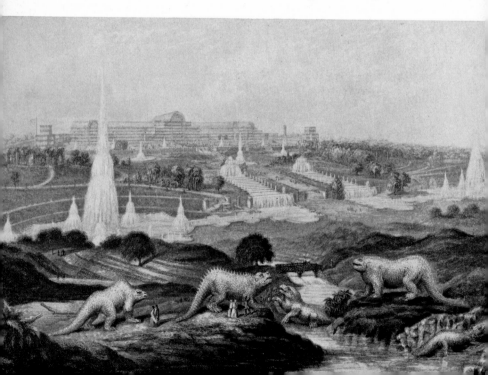

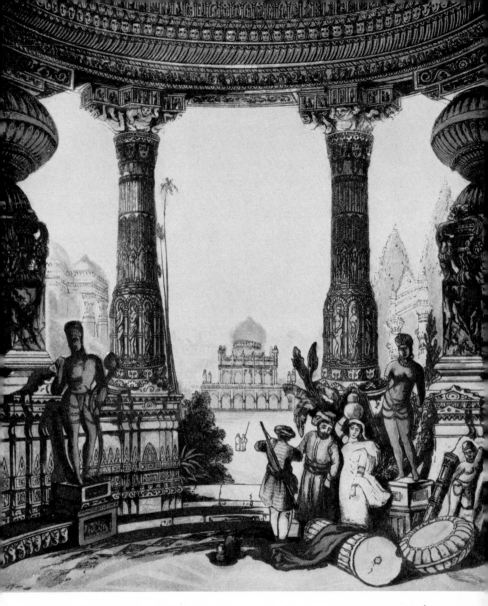

PLATE 79 *Hindoo and Mohammedan Buildings* – the sculptured port- ▲
ico of a temple at Moondheyra in Guzerat, ascribed by the natives
to the deity Rama. Oil colours were not used in the first edition
of this print in 1834, and the later editions of 1835 probably
give the first example of Baxter's use of this method.

PUBLISHED Aug. 18. 1853 BY
GEORGE BAXTER
PROPRIETOR & PATENTEE

◀ **PLATE 80** *Copper, your Honour?* – a Baxter portrait of a character well known in the streets of London as a crossing-sweeper who obtained coins from passers-by in appreciation of his humour. It was probably adapted from a contemporary picture. First published in 1853, and made from eight coloured blocks, the prints sold originally for one and sixpence in the print shops.

PLATE 81 *The Soldier's Farewell, the Parent's Gift* – the ▲ departing guardsman is handed a Bible by his father amid a landscape buried in snow, emblematic of the hard times endured by the troops during the disastrous campaigns in the Crimea. First published by Baxter in 1855, and later by Le Blond under licence.

▶

PLATE 83 Baxter oil colour print of the *Boa Ghaut* from a painting by W. Westall representing an incident at the Battle of Assaye, which established Wellington's fame and secured the dominion of England over India. Published in 1837, there are two versions of this print, one having fewer figures than the other.

▼

PLATE 82 Monochrome print by Baxter of the Dover Cliffs, 1853. The engraving of the waves and ships is of particularly high quality.

PLATE 84 *Castle, Gordon, Morayshire* by R. Sands and published by George Virtue in 1837. The print is hand-coloured and typical of the prints of well known houses, country seats and hunting scenes whose popularity lasted from the eighteenth century well into the Victorian period, and which were eagerly snapped up in the print shops of London and the provinces.

PLATE 85 *So Tired,* a print from a painting by F. X. Winterhalter (1805–1873) of a girl resting on a large red couch. As Winterhalter was a favourite of Queen Victoria's, it is possible that the girl represents the Princess Royal. The original print was by Baxter, but Le Blond later used the plates, and though there is less bloom in the cheeks, his version is still excellent.

PLATE 86 Church scenes were always very popular among valentine buyers. This embossed and gilded paper valentine, with a luxurious decoration of paper flowers around its border, opens to reveal a marriage ceremony in progress inside the church.

VALENTINES

Nothing is more typical of the Victorian Age than the valentine. Prodigious numbers were produced and sent, and as late as the 'eighties the Post Office issued an annual appeal for early posting on the eve of St. Valentine's Day. Nobody seems to know why St. Valentine, a saintly bishop martyred by the Romans, came into the story at all; but it is certain that from the fifteenth century at least the chosen sweethearts for the coming year were called one another's valentine. At the Court of Queen Elizabeth lots were cast every year for valentines, and in the next century it had become the custom to present the lady in the case with a handsome gift of gloves or stockings.

Paper valentines appeared towards the end of the eighteenth century and were at first elaborately written out and hand-painted. Soon etching and lithography were called in to provide an outline design which could be coloured by hand, but it was not until the late 1840s or early 'fifties that the valentine reached its most characteristic form of a card adorned with paper lace with the addition of bows of ribbon, pressed flowers, metal hearts and other decorative trifles. The pioneer manufacturer of these was H. Dobbs, "Ornamental Stationer" to the Royal Family.

Gold-bordered valentines were popular in the 'forties, produced by blowing bronze powder on to a varnished lithograph

while it was still tacky, at considerable danger to the lungs of the girls who did the work. It was the French who invented the flower-cage valentine, but these were soon copied in London and enjoyed considerable vogue. In the centre of the card was a posy of printed flowers and when this was lifted by means of a string it resolved itself, by means of clever cutting, into a bird cage with a Cupid, or two doves or some other suitable emblem inside.

Another kind of trick valentine had what was called a pocket-centre which when opened disclosed another scene, as for example the inside of a church with a marriage ceremony in progress, or the cabin of a ship showing a sailor pining for his beloved. Naturally enough, this type was very popular with mariners and was usually adorned with such cracker-motto verse as

> Tho' distant climes may us divide
> To think on you shall be my pride
> Tho' Winds and Waves may prove unkind
> In me no change you'll ever find.

This is a really remarkable profession of constancy for a sailor, and we can only hope that he did not buy his valentines by the dozen and leave one in every port.

Another kind of trick valentine showed a figure which moved a limb when a cardboard lever was pulled; and there were others which could hardly have been approved of by the Victorian papa, which depicted a young lady in a perfectly respectable crinoline dress, but when the lever was pulled she lifted her skirt and showed one inch or so of white drawers.

Among the rarest of surviving valentines are the imitation banknotes, telegrams and postal orders. They are rare because the Bank of England and the Post Office succeeded in having them prohibited. Very popular were the perfumed valentines, a scent sachet impregnated with patchouli and enclosed in a silk cover.

So great was the annual output of valentines that it was estimated in 1875 by Rimmel of the Strand, the leading valentine manufacturers, that no less than 10,000 women were employed in the trade. The valentine was killed partly by the increase in the number of vulgar or satirical cards and by the growing popularity of Christmas cards. By the end of the century the valentine may be said to have ceased to exist. Its revival in our own day is just part of our interest in all forms of Victoriana.

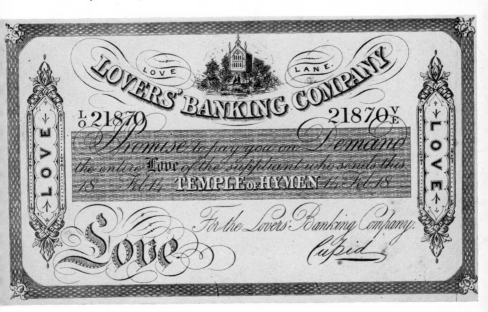

PLATE 87 Engraved valentines in the form of banknotes, with the promise to pay the recipient love on demand, appeared in the 1850s, only to be suppressed because of their confusing similarity to real banknotes.

PLATE 88 A delicately coloured and embossed
paper valentine, with a lithographed portrait
of a girl in the centre panel.

PLATE 89 Birds, usually engaged in nest-making, are a constantly recurring feature of the Victorian valentine. This card has gilded edging and silver leaves and branches.

PLATE 90 Some valentines became choked by their own extravagance. Here we have a central scene with a church, cameo-style figures, shells, feathers and gilt decoration.

PLATE 91 Valentine designed by Walter Crane ▶
and published by Marcus Ward & Company.
There was nothing particularly seasonal about
the cards Crane made, and many were used
both as valentines and as Christmas cards.
Marcus Ward & Company drew on the talents of
many artists of repute, and the constant
supervision of Walter Crane's brother Thomas,
director of the firm's department of design,
maintained the high standard of their cards.

Allow me to present My Bill.

February fo. 799.

To Miss...

To paying sundry visits and attentions	75
Ten Packets of best love mixture	180
"Advice" on Courtship & Matrimony with practical illustrations }	60
Writing love letters	80
Sighs & Tender-smiles	50
Seeing home	200
Compensation for doctors bills palpitation of the heart giddiness. &c }	300
Paying addresses	55
Kisses	1000

*Payment having been long delayed it is tenderly requested that settlement
may be made at St Brides Church, by special license as speedily as possible, so
do not send a* cheque.

▲ **PLATE 92** Not all the Victorian valentines
displayed the expected sentimentality and the
obvious features of churches and nesting birds.
Some, like this one, were quite inventive,
and others used rather heavy puns, like the
card with a piece of shoe-leather attached
and the inscription, "You're a good old sole".
Some slightly *risqué* cards even drew attention
to the physical deformities or the remarkable
unloveliness of the recipient.

PLATE 93 Cupid, diff-
used with a pink glow,
rests among the flowers.
This is the cover for a
small book of romantic
poems and illustrations
suitable for despatch
on St. Valentine's Day.
Published in London
by Earnest Nister.

▼

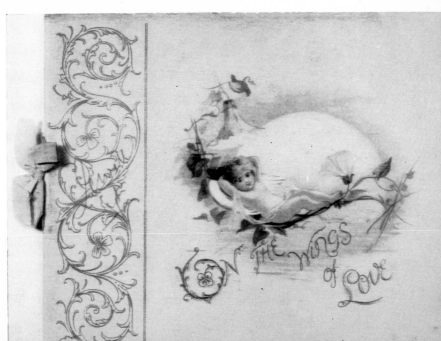

ON THE WINGS of LOVE

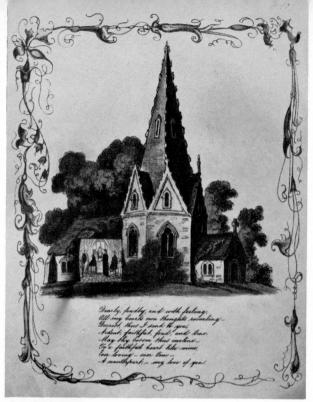

Dearly, fondly, and with feeling,
All my heart's own thoughts revealing—
Dearest, this I send to you,
Ardent, faithful, fond, and true.
May they [...], [...] [...]
Of a faithful heart like mine,
Ever loving—ever true—
A counterpart—my love of you.

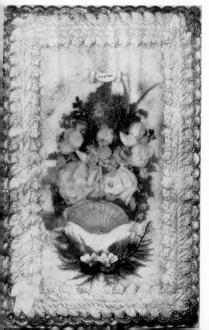

PLATE 94 Lithographed mechanical
valentine, the doors opening to show
the marriage taking place within.
This valentine is unmarked, but
similar church mechanicals were made
by Dean & Company in London.

PLATE 95 Valentine composed of layers
of paper embossed in a pattern of
leaves and with gilded edges. The
coloured paper flowers in the basket
are kept in place by fine gauze
secured to the bottom layer of paper.

PLATE 96 Embedded in brightly coloured
foliage like a bird's nest, the lover's house
rests on a rich, blue backcloth, and is sur-
rounded with embossed silver paper-lace.

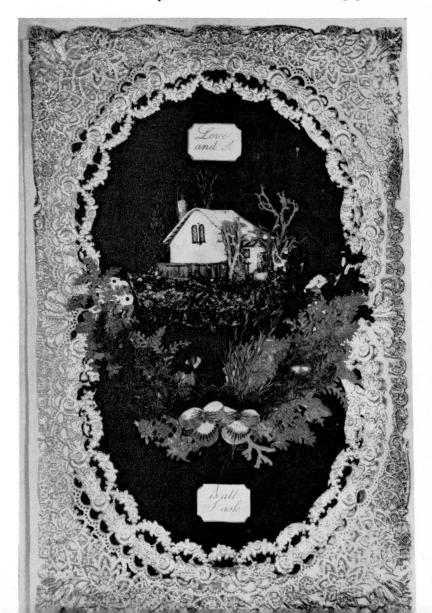

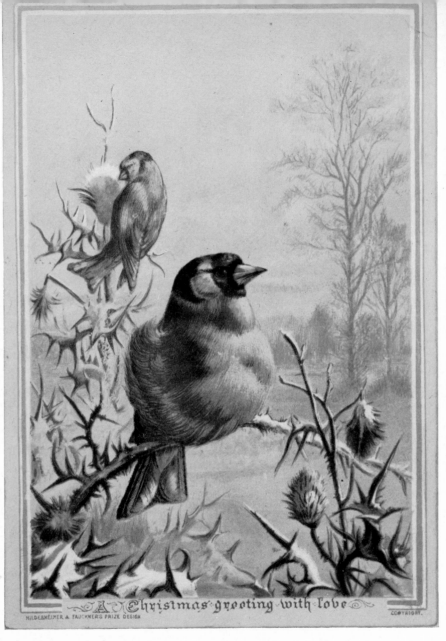

A Christmas greeting with love

HILDESHEIMER & FAULKNERS PRIZE DESIGN

COPYRIGHT.

**PLATE 97 Robins made a particular appeal to Victorian sentiment-
ality, and figured on an immense number of Christmas cards.**

CHRISTMAS AND GREETINGS CARDS

The Christmas card took a surprisingly long time to get itself invented. For a whole generation there had been valentines, but at last the manufacturers of such trifles tumbled to the idea that while people (nice people, anyway!) sent only *one* valentine, the nicer you were the more Christmas cards you were likely to send. After that the valentine was relegated to a minor place and the Christmas card conquered the world.

There has been much controversy about the first Christmas card, but it has now been established that John Calcott Horsley was asked by Henry Cole (later Sir Henry Cole and first Director of what is now the Victoria and Albert Museum) to design a Christmas greeting for Cole's friends. This was in 1843 and five years later another card was designed by W. M. Egley. The cards published by Messrs. Goodall in 1862 were probably the first issued to the trade (the Horsley and Egley cards having been private ventures) and by the early 'seventies the Christmas card had established itself and the real spate began.

The early Christmas cards closely resembled the valentines they were superseding, with paper lace borders. Thierry of Fleet Street launched elaborately embossed reliefs, and frosting made from fine glass blown into thin bubbles and burst was introduced in 1867 by a manufacturer called King.

The trick card is in a category by itself. Some were so elaborate

as to be almost mechanical toys: soldiers who could move their legs, bouquets that opened out into sprays of flowers when a string was pulled, doors that opened to reveal the festive scene inside, or even a double card which revealed when opened an elaborate scene of the Nativity with cut-out figures and the stable, complete with roof and with angels singing carols on the top. It is a pity that this kind of card seems to have gone out of fashion. It would still give much pleasure in the nursery.

To the modern eye the most attractive of the old cards are those which have retained most completely their period flavour. The Aesthetic craze of the late 'seventies and early 'eighties, known to most people by the *Punch* cartoons of Du Maurier and the melodies of *Patience*, produced a whole crop of cards intended to ridicule the "intense" and the "utterly utter". The Aesthetes themselves, of course, never exchanged cards of this character but sent instead chromolithographs of early Italian paintings imported in large numbers from Germany and affixed to the English manufacturer's product.

In the 'nineties there was a fashion for comic cards, some of which could hardly be called cards at all: cork soles (facsimiles, of course) and banknotes ("Pay to Bearer a Thousand Good Wishes"), corkscrews (with which to open the bottle of Christmas cheer), empty envelopes and a thousand such devices of the practical joke order.

Several firms employed Royal Academicians to design their cards, and many well-known artists occasionally turned their hands to this humble but profitable task. Walter Crane was one of the most successful, but the most charming was Kate Greenaway. That she lent an extraordinary grace to her pictures of children few could deny, for Kate Greenaway is one of those artists who have never quite gone out of fashion. To her contemporaries the most attractive part of her work was her habit of clothing her little characters in the habits of a former day; but to us she is at her most delightful when she gives us a glimpse of her own times.

STMAS
TING

friends a joyous meeting
neb shall bear a part,
ke a Christmas greeting
... mid mind and heart.

sister or a brother,
welcome be to-day,
as we greet each other
s who are far away.

nur this happy season,
nful thought intrude;
re has the aid of reason
oy is gratitude.

MAY HAPPY RETURNS OF THE DAY

▲ PLATE 98 Christmas card pub-
lished by Marcus Ward & Co.
and designed by Thomas Crane.
The card is beautifully decor-
ated with an architectural
design and leaf pattern,
richly gilded and coloured in
dark reds and greens.

▶

PLATE 99 Card with familiar
Christmas morning scene.

I send my love at Christmas.

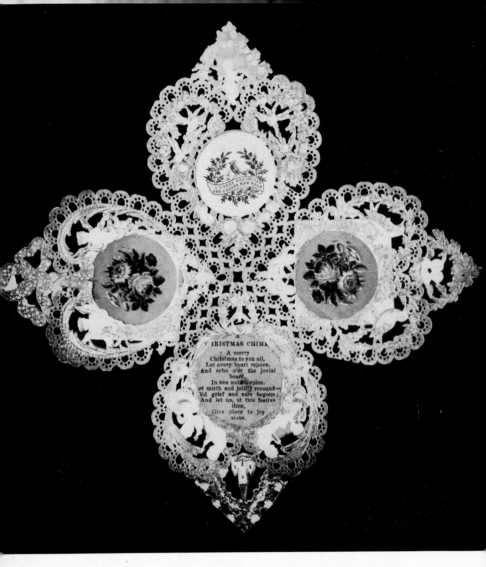

▲ PLATE 100 A paper-lace Christmas card in silver and white, with
panels of flowers and verses, decorated with embossed churches
and birds around the edge. Folded, it forms a heart-shape.
One of the rarer and more charming early Christmas cards.

PLATE 101 At first the Christmas card bore no distinct features of its own. This card, in fine quality paper lace with a hand-painted bird in the centre, would have done as well for a valentine card had the inscription been different.

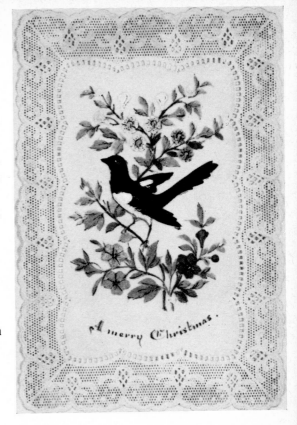

PLATE 102 As the fashion for sending cards at Christmas caught on manufacturers realised the possibilities for the advertiser. In the American card below little attention has been paid to design, but it probably succeeded in amusing customers.

PLATE 103 Calendar for 1884 by Kate Greenaway. Most of her ▶
cards were published by Marcus Ward & Company until she quar-
relled with them in 1878 and turned to the printer Edmund Evans.
This calendar, decorated with dancing, long-frocked girls, was
one of a series published by George Routledge & Sons in 1884.

PLATE 104 Almanack for 1875 in the form of a fan, published by
Dean & Sons, who produced a great number of the early animated
▼ cards, both comic and sentimental, as well as Christmas notepaper.

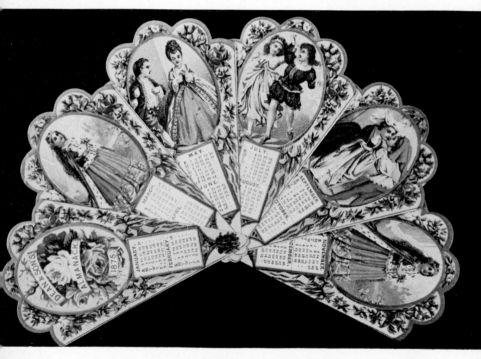

PLATE 105 New Year Card published by Marcus Ward & Company and
designed by Kate Greenaway. Her popularity and the influence of
the costumes of her child figures was such that by the end of
the century her style was known even in France as "greenawisme".
Together with the rather different designs of W. S. Coleman
depicting scantily dressed classical maidens, Kate Greenaway
supplied almost the whole of the vast market for children's cards. ▶

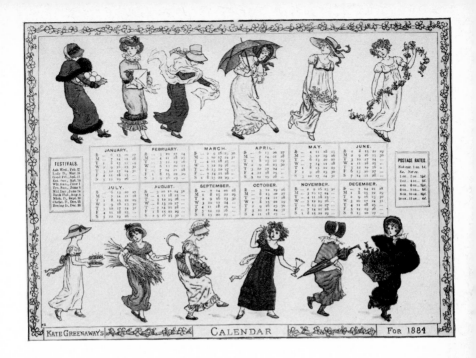
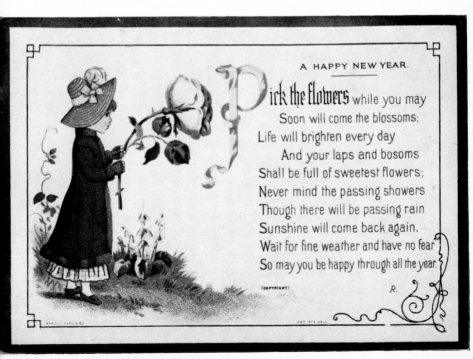

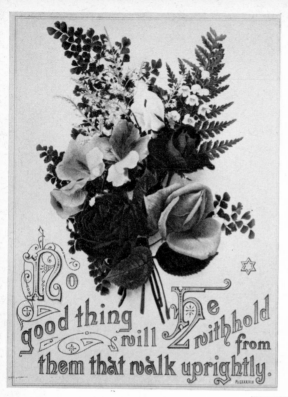

No good thing will He withhold from them that walk uprightly.

PLATE 106 Cards quoting passages from the Bible in richly decorated lettering were issued at Sunday Schools and were popular decorations for mantlepieces in middle-class Victorian homes.

PLATE 107 Scenes depicting emancipated women bicycling in bloomers, playing sports, or taking part in other manly activities formerly denied to them, made good topics for greetings cards towards the end of the century.

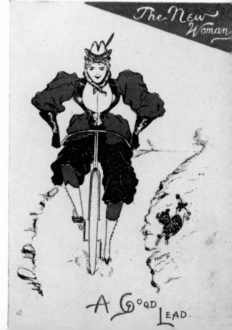

The New Woman

A Good Lead.

PLATE 108 Birthday trick
card. By pulling forward
the top layer of paper, an
impression of depth was
created in the coloured
background picture.

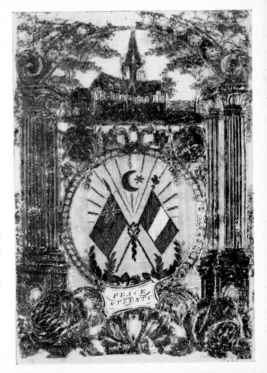

PLATE 109 An unusual card,
picked out in gold and
coloured threads, with the
flags of England and France
and the Turkish crescent,
probably issued at the end
of the Crimean War in 1856.

PLATE 110 Music cover designed in the style of Miles Birket Foster (1825–1899), the water-colour painter, perhaps the best known artist of the period in the sphere of rustic romanticism.

MUSIC COVERS

The heyday of the coloured music title was from 1860 to 1890. There had been monochrome versions before this and lithographs coloured by hand, but by the late 'fifties it was possible to print them in colour, and the real torrent began. Thousands were issued as covers for the sentimental ballads and comic songs which played so large a part in Victorian entertainment.

Some of the most interesting are theatrical, for every popular song was sold in the music shops as a matter of course, and the score was almost always adorned with a picture of the man or woman who had made the song popular. George Leybourne launched many such songs, of which *After the Opera* was one of the most successful, and on the cover of this we can see the figure of Lord Dundreary, with his famous whiskers, swaggering at Cremorne. Incidentally most of the few records that remain to us of Cremorne and other gay resorts are to be found on music titles.

Every aspect of social history is reflected as, for example, the enormous excitement caused by Mrs. Bloomer; and all the games of the period are represented: toxophily (the grand name for shooting with bows and arrows), croquet, tennis and bicycling. There are military and naval uniforms of all kinds to accompany popular patriotic songs about the Crimean War and the Indian Mutiny.

But perhaps the greatest charm and value of music titles is as a revelation of the sentiment of an epoch and of a sentimentality which we find merely funny. Such titles as *She Sleeps Beneath the Daisies on the Hill*, or *Little Sister's Gone to Sleep* (complete with dead little sister in brass-knobbed bedstead and elder sister putting away the now unwanted toys) tell their own story. In a slightly more cheerful vein we find such gems as *Angels are Watching over Thee*, and with an even more pointed moral: *Don't Sell No More Drink to My Father*.

PLATE 111 Design incorporating a portrait bust of Jenny Lind (1820–1887), probably the most widely pictured of the stage characters of the time, who achieved outstanding success as an opera and concert hall singer in Britain and the United States in the middle years of the nineteenth century.

PLATE 112 Design by Alfred Concanen for a music cover for Christmas 1868 featuring the conventional attributes of Victorian Christmastide – snow, holly, old houses and a coach and horses – as popularised by the *Christmas Tales* of Charles Dickens.

CHRISTMAS EVE.

CHARACTERISTIC PIECE.
FOR THE PIANOFORTE,
BY
W. H. HOLMES.

PLATE 113 This lithographic design reflects the growing interest in the remoter and more exotic regions of the earth, of which the novels of Jules Verne – *Around the World in Eighty Days* (1873) for example – was symptomatic.

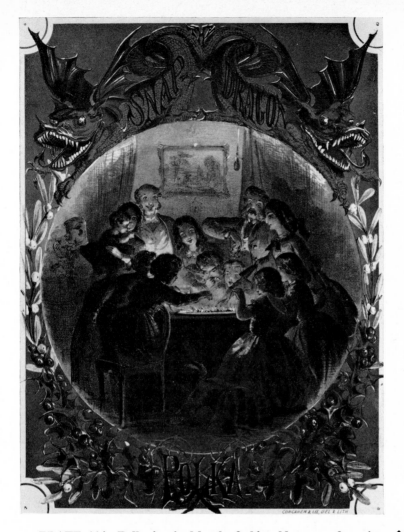

PLATE 114 Polka inspired by the fashionable game of pouring ▲
brandy over a plate of almonds and raisins and igniting it.
The contestants had to try to remove them from the plate without
burning their fingers. The Victorians were not daunted by the
difficulties of inventing a tune to suit such unlikely topics.

◀ PLATE 115 This "comic" design for the Lancers,
which was at the height of its popularity in the
middle of the century, reflects very strongly
the earlier influence of Rowlandson and Leech.

THE
SIREN GALOP.

JAMES CASSIDY
COMPOSER OF THE POPULAR COLLEEN BAWN QUADRILLE ILLUSTRATED IN COLOURS, Pr 4/.
LONDON PUBLISHED BY JOHN BLOCKLEY, PARK ROAD, HAMPSTEAD. N.W.
CRAMER BEALE & WOOD, 201 REGENT STREET. W.

◀

PLATE 116 Typical design in a highly romantic style of the latter end of Victoria's reign.

PLATE 117 Design picturing episodes from *Monte Cristo* by Alexandre Dumas (1802–1870). The composers of the period wrote Quadrilles and Galops to many of the popular novels. ▶

PLATE 118 One of the fashionable pastimes of Victorian ladies and gentlemen, of which Elizabeth Barrett Browning was an early adherent, was experimenting in the realm of spiritualism and mesmerism. ▼

THE DARK SÉANCE POLKA.

BY
J. H. ADDISON

Theatre-Royal, Dunlop Street,
LESSEE.
MRS EDMUND GLOVER.
(Authorised to Perform the Pieces of the Dramatic Authors' Society.)
GLASGOW
MANAGER.
MR CHARLES G. HOUGHTON.

Doors Open at HALF-PAST SIX—Curtain to Rise at SEVEN.

MONSTRE PERFORMANCE!

LAST NIGHT OF THE THRILLING DRAMA OF

EAST

LYNNE

In which the Distinguished Metropolitan Artiste MISS

HEATH

Will appear, assisted by Mr GEORGE

GRANT

MASTER TOM BOULTON
—Will appear in TWO CHARACTERS, as WILLIE CARLYLE, and as
KING RICHARD In the Fourth Act of RICHARD III.

This Evening, SATURDAY, 12th May, 1866,
The Performances will commence with a New and Original Play, in Four Acts, dramatised expressly for Miss HEATH and Mr GEO. GRANT, by J. B. JOHNSTONE, Esq., from Mrs Henry Wood's charming Novel of the same name, and entitled

EAST LYNNE

PLATE 119 Poster advertising *East Lynne,* an adaptation for the stage of the novel by Mrs. Henry Wood (1814–1887). Its theme: that the sin of a married woman is unpardonable, and the reward for running away from one's husband eternal unhappiness.

MELODRAMA AND OTHER POSTERS

The pictorial advertisement (for that is what a poster is) has a long history. One might say that the swinging signboards which once so much enlivened the streets of Elizabethan London were, in essence, posters. Eighteenth-century broadsheets sold in multitudes after murders showed the same kind of striking design, intended to seize the attention at first glance. Playbills were not, at first, pictorial but they too must be reckoned among the ancestors of the poster. The true poster only came into existence towards the second half of the nineteenth century, for it was only then that the progress of mechanical reproduction enabled large designs to be multiplied in colour.

The melodrama poster was comparatively small in size and the designers were more concerned to move the emotions than to produce a work of art. The method was one of highly coloured realism depicting scenes from such popular favourites of the transpontine stage as *The Lights of London*, *East Lynne* and *Uncle Tom's Cabin*. Immense numbers were produced, for the most part designed by men whose names have faded into obscurity.

The poster with some pretensions to be a work of art was inaugurated by Jules Chéret. He was born in Paris but served his apprenticeship as a lithographer in England. In 1866, profiting by the introduction of large lithographic stones, he launched out on his career as the most prolific poster artist of all time,

specialising almost entirely in theatre advertisements. His methods were taken up by a greater artist, Toulouse-Lautrec, who raised the poster to perhaps the highest excellence it will ever reach.

The first English theatrical poster of any note was designed by Fred Walker for *The Woman in White*, produced in 1871. This, however, was not a colour lithograph but a monochrome wood-engraving. The Beggarstaff Brothers (William Nicholson and James Pryde) made their posters by building up the design in cut-out layers of different shades of brown paper. In the mid-nineties Aubrey Beardsley designed posters in his characteristic style and Dudley Hardy produced simple and effective designs for a number of plays. But in this field of art the French were undoubtedly supreme, and we can hardly include all their many masterpieces in a survey of Victoriana.

PLATE 120 *The Octoroon, or Life in Louisiana,* **first presented by Dion Boucicault (1822–1890) at the Winter Gardens in 1859. Inspired by the slavery issue brought up during the Kansas Elections.**

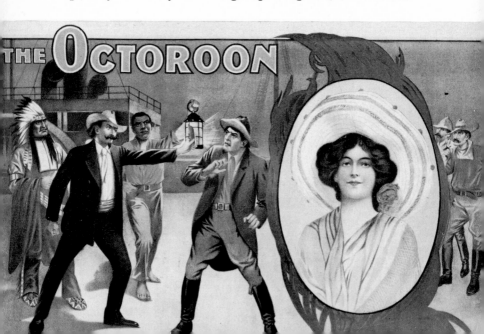

PLATE 121 *The Silver King*, first produced in 1882. It contained all the elements of the classic Victorian melodrama – an innocent person believing himself guilty of a crime he has been falsely accused of; a hungry persecuted heroine; an evicting landlord, murdering villain and haughty aristocrat combined into one; Cockney comic relief; and the final triumph of virtue.

▲ PLATE 122 *Jane Shore*, adapted by many playwrights from time to time, this version was for the Theatre Royal, Bath, probably about 1880. "See with these dying hands I take off the curse and place it on my Soul" the quotation reads.

PLATE 123 The moment of accusation, from *The Plunger*. ▼

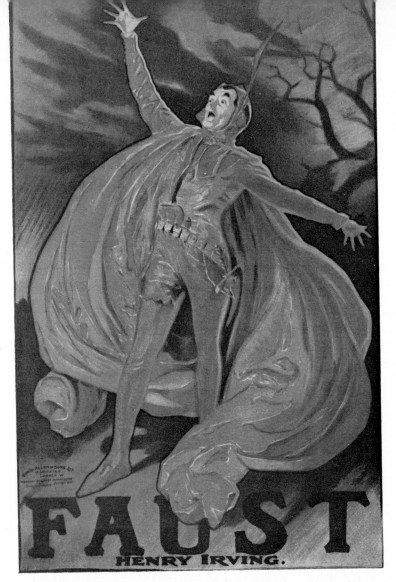

PLATE 124 Poster for Wills's version of Goethe's *Faust*, performed
at The Lyceum in 1885 with Sir Henry Irving (1838–1905) as
Mephistopheles, and Ellen Terry (1848–1928) as Marguerite, one of
the greatest successes of their partnership at the Lyceum. The
poster is unsigned but was probably designed by Bernard Partridge.

THE ROSE OF PERSIA

BY BASIL HOOD AND ARTHUR SULLIVAN.

Dudley-Hardy.

"D'OYLY CARTE'S
OPERA COMPANY."

PLATE 125 Poster advertising Bechstein pianos ▲
by Louis Rhead, the painter, in the flowing Art
Nouveau style. The light-coloured mass
of the dress derives from Beardsley's
drawings. Art Nouveau advertisement posters
reached a very high standard, and attracted
artists of considerable merit.

◄ PLATE 126 Poster by Dudley Hardy (1865–1922)
for *The Rose of Persia,* a comic opera by Basil
Hood with music by Arthur Sullivan (1842–1900)
performed by the D'Oyly Carte Opera Company
at the Savoy in 1899. D'Oyly Carte was the
first person in this country to realise the
possibilities of the poster as a medium for
the really accomplished artist, and made it
his policy to encourage Dudley Hardy by
attaching him to the Savoy as their regular
designer. In this poster, with its mass of
white and restrained use of colour, Hardy
was evidently much influenced by Beardsley.

PLATE 127 **Mr. Elton as** *Richard Coeur de Lion.* **Richard's glinting armour and jewellery is made of tinsel and secured on a printed background scene with a medieval castle and a Crusader's tent. His stance is the conventional one for this kind of picture as is the look of perpetual surprise on his face.**

TINSEL PICTURES
AND JUVENILE DRAMA

Within the last generation there has been a considerable revival
of interest in the toy theatre. Robert Louis Stevenson's charming
essay, *Penny Plain and Twopence Coloured* (written in 1884), was
re-discovered, the Sitwell's ballet *Britannia* used one of the
scenes as a backcloth and enthusiasts began to make a pilgrimage
to Hoxton to the little shop where Samuel Pollock and his
daughter still contrived to carry on the trade. When the business
was given up the sheets and plates were purchased and preserved,
and in 1925 the British Model Theatre Guild was formed. The
"Juvenile Drama" had become fashionable which, one might
add, it had never been before, however popular it may have
been in the Victorian nursery.

The prints which Stevenson had seen as a boy in Edinburgh
and which had fascinated him by their "gesticulating villains,
epileptic combats, bosky forests, palaces and warships, frowning
fortresses and prison vaults", bore the name of Skelt as the
publisher, and it is because Stevenson thought that the name
Skelt was so "stagey and piratic" and "always seemed a part
and parcel of the charm of his productions" that the toy theatre
as a whole is often referred to as "Skeltic Melodrama". In
reality Skelt was only one of many publishers in the same field.
At the height of its popularity there were no fewer than fifty
firms engaged in the business.

The child's theatre as we know it was begun by one of three men, Green or West or Lloyd, and the ealiest sheet is dated 1811. It is thought by some scholars to have originated in Germany at the end of the eighteenth century and to have had some connection with the "Christmas Crib". It seems, however, to be more plausibly derived from the theatrical portraits so popular at the time. These were known from the time of Garrick but in the Regency period they took on a cruder, more popular form. They are not crudely drawn; the actual technique of the draughtsmanship is, indeed, too sophisticated; it is the end of a long tradition. But the figures themselves have a curious artlessness, the freshness of approach of a peasant or a child. It is as if popular art, the *image d'Epinal*, or its English equivalent, the eighteenth-century broadsheet, had suddenly risen to the surface. Yet they were not originally intended for children. Grown-up people bought the tinsel pictures of popular actors and actresses in the same way as the Edwardians bought picture postcards of Gladys Cooper. Sometimes they were already tinselled; sometimes the prints and the little tinsel fragments were bought separately, thus supplying the materials for a home craft.

The attitude of the actors, which was to be carried over into the "Juvenile Drama", is one of the most curious conventions in the history of art. With one knee bent and one leg straight the figures lunge forward like a fencer completing a thrust. Was this an idiosyncrasy of the elder Kean, or is it a mere trick of some theatrical draughtsman, perpetuated and crystallised into tradition? Perhaps this stance of exaggerated action is nothing more (or nothing less) than Romanticism narrowed to a gesture.

The transition to the child's theatre began when several actors from the same play were depicted on one sheet. From that it was an easy step to showing scenes from the play with back-cloth and cut out wings in the theatrical convention of the time, the tradition of baroque staging with its flats and borders. With the coming of realism and the "box-set" towards the end of

the century the connection between the real theatre and the "Juvenile Theatre" was severed and the latter soared into the realm of fairy-tale. Its charm is to remind us that fairyland was once the land of every day, and for that reason perhaps is a truer picture of the furniture of men's minds during the Victorian period than many more ambitious and self-conscious works of art.

PLATE 128 Park's Shakespearian Twelfth Night characters. The figures were cut out and mounted on cardboard.

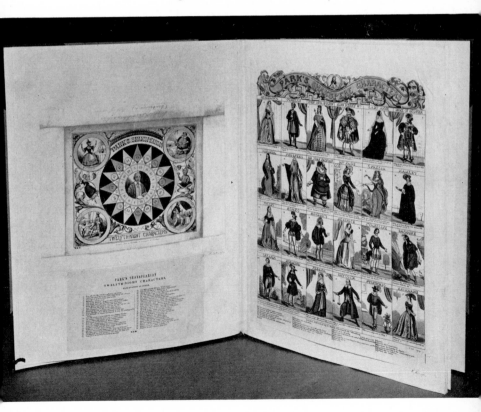

THE FAVOURITE SCENE FROM VALENTINE AND ORSON
As Performed at Sadlers Wells Theatre.
ORSON M[r]GRIMALDI. VALENTINE M[r] HARTLAND
Child : M[rs] Gladhill.

PLATE 129　A favourite scene from ▲
Valentine and Orson, an early
French romance about two banished
children, one of whom is reared
by a bear, the other brought up
as a knight by King Pepin.
Joseph Grimaldi, who played the
"wild man" was a well known
Victorian pantomimist.

PLATE 130　This tinsel warrior –
he might be a Crusader or just
a medieval knight – is drawn in
an almost identical pose to that
of King Richard in plate 127.
◀

PLATE 131 Some of the characters in *Anthony and Cleopatra*. Only the hands are used to convey feeling, the faces being left quite neutral and without individual characteristics.

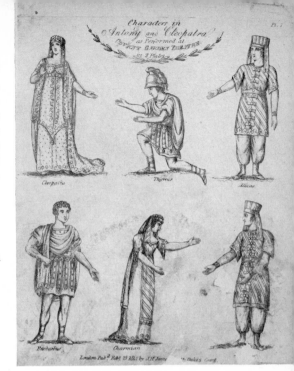

PLATE 132 Characters from *The Boys of England*, each fraught with some powerful emotion and engaged in violent and dangerous business. In spite of their stylised poses, the nature of each character is left in no doubt.

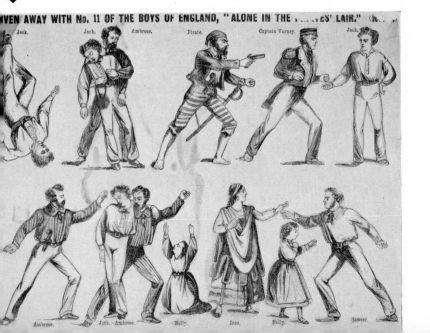

GIVEN AWAY WITH No. 11 OF THE BOYS OF ENGLAND, "ALONE IN THE PIRATES' LAIR." (N...

SKELT'S JUVENILE DRAMA.

ALADDIN,

A DRAMA,

IN TWO ACTS,

Written expressly for, and adapted only to

SKELT'S CHARACTERS & SCENES

IN THE SAME.

LONDON:

Printed and published by B. SKELT,

AT HIS WHOLESALE AND RETAIL

THEATRICAL WAREHOUSE,

17, SWAN STREET,

MINORIES.

Sold by all Theatrical Book and Print Sellers in
Town and Country.

PRICE FOURPENCE.

PLATE 133 Cover for Skelt's characters and scenes in *Aladdin*, sold, as it indicates, in the theatrical book and print shops.

◀

PLATES 134–136 Webb's characters and scenes in *Aladdin*. These were sold either "penny plain or twopence coloured", and the children themselves could then cut them out and use them for their presentations. Even separate pieces of furniture were supplied with the scenes.

▼

Scene 9th WEBB'S SCENES IN ALADDIN. No 8

London. Pub. by W. WEBB. 146. Old Street, St. Luke's

WEBB'S CHARACTERS IN ALADDIN. Plate 6

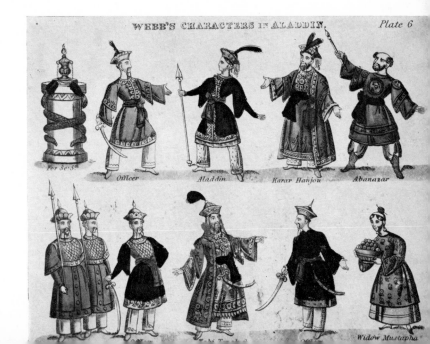

For Sc. 5.th Officer Aladdin Karar Hanjou Abanazar

Widow Mustapha

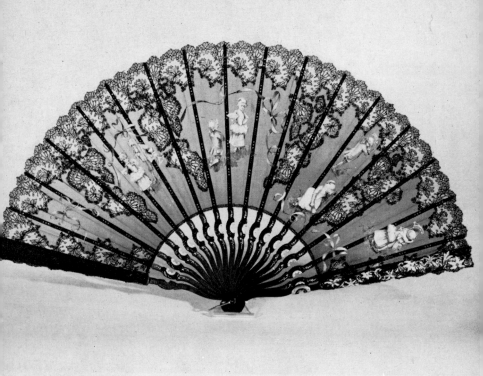

PLATE 137 An anecdotal fan of about 1880,
showing a quarrel between lovers. The fan is
made of black net on which the lovers have been
hand painted in Kate Greenaway style costume.
The sticks are of blackwood painted and gilded
and around the figures is a decoration of
appliquéd black lace in a flower pattern.
Taking into account the painters, the mounters,
and the stick-makers, as many as twenty-one
people were involved in the making of one fan.

FANS

It would be absurd to pretend that Victorian fans are in any way comparable with the masterpieces of the eighteenth century. For one thing the fan no longer played so large a part in social life, being, except in Spain, largely relegated to the evening. The fans of the 'forties were small and sometimes decorated with sequins. About 1850 there was a fashion for "Cora" fans of coloured feathers, and a little later for fans painted in water-colours. Most of these came from France and were decorated by some quite well-known artists, of whom Duvelleroy was the most notable. Cheaper fans were produced by means of lithography, the prints being usually coloured by hand. The influence of the Empress Eugénie was responsible for the importation and imitation of Spanish fans, and later, in the 'eighties, there was a passion for everything Japanese. It was at this time that fans began to be used in the decoration of rooms. In fact, the fan (not in the hand but on the wall) was as much a mark of the true Aesthete as the inevitable sunflower. Some of these fans were genuine imports from the Orient, but most of them were imitations, manufactured in England.

Towards the end of the century large ostrich feather fans became fashionable, although these are perhaps more typical of the Edwardian epoch. Small fans of spangled gauze or lace appliqué were also popular. Some of these were not without

charm, but the heyday of the fan was over, perhaps because, with the coming of electric light, ballrooms were no longer so overheated as they had been when lit with innumerable candles.

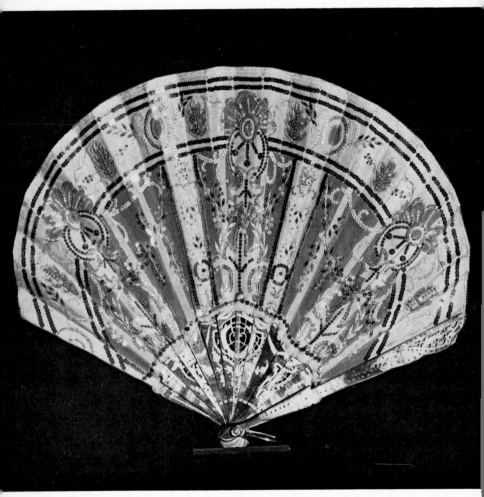

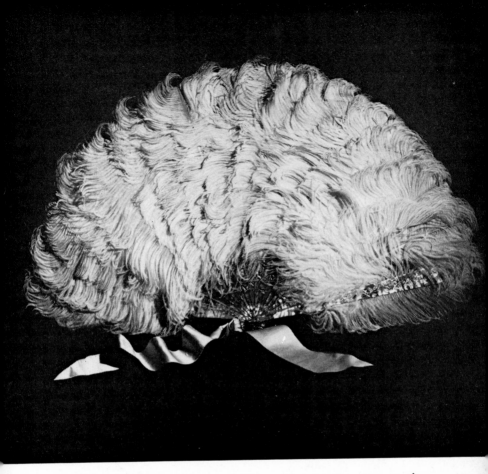

PLATE 139 White ostrich feather fan with painted mother-of- ▲
pearl sticks made by Tiffany & Co., the New York jewellers,
in 1878. Fans of this kind, with the feathers often coloured
bright green or red, are still easily obtainable in the
antique markets for a few pounds, though usually they have
wooden rather than mother-of-pearl sticks.

◀ PLATE 138 A small shell-shaped fan of about 1850, the sticks
of silver-coloured mother-of-pearl and the white net material
decorated with silver and coloured spangles.

PLATE 140 Peacock feather fan of the 1870s with fragile ivory ▶
sticks and a hand-painted scene in the Chinese style, probably
made in England for the devotees of "aesthetic" decoration.

PLATE 141 Chinese fan in ivory brisé, the design of birds,
figures and houses picked out in minute and delicate detail
on a background of tiny threads of carved ivory. On the
sticks a design in relief of a dragon and small figures.
To achieve the precision required in such delicate work
▼ many of the Chinese brisé fans were carved under water.

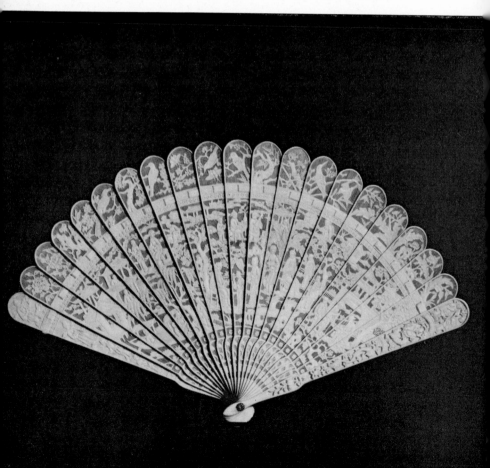

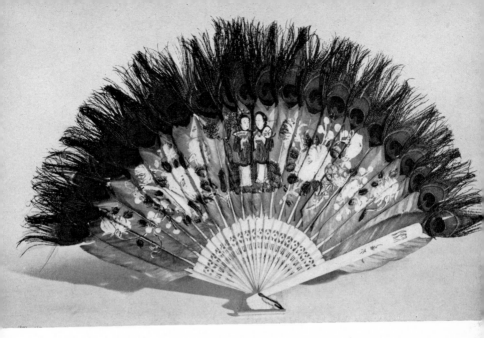

PLATE 142 Fan in the Spanish style, the sticks of wood with
silver decoration. The material is satin decorated with a
painted scene depicting figures outside an inn. ▼

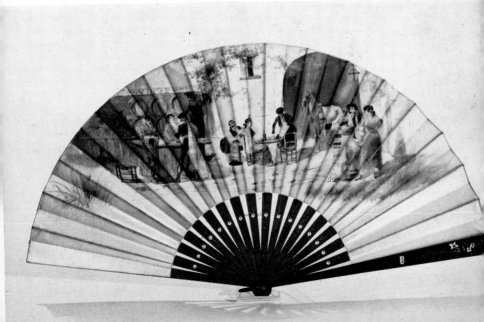

PLATE 143　A lithographed and painted fan of
the 1840s, probably a copy of an Eighteenth
Century riverside scene. Though there has
been a certain coarsening of style since the
previous century, apparent in the heavy
silver and gilt decoration on the ivory
sticks, the lithographed scenes are often
very pleasing, with fine detail and colouring,
and such fans are easily and cheaply collected.

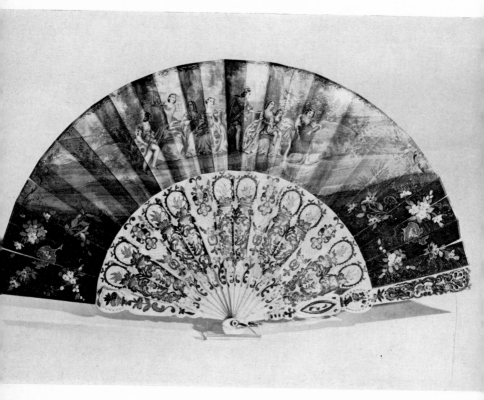

PLATE 144 An exceptionally fine white Nottingham lace fan in a flower and leaf pattern, with sticks of mother-of-pearl also decorated with flowers. In the centre panel is the figure of a girl in a romantic pose and early Nineteenth Century costume. She has been hand painted on to the net, the artist being so economical in his use of paint that if the fan is held up to the light she disappears.

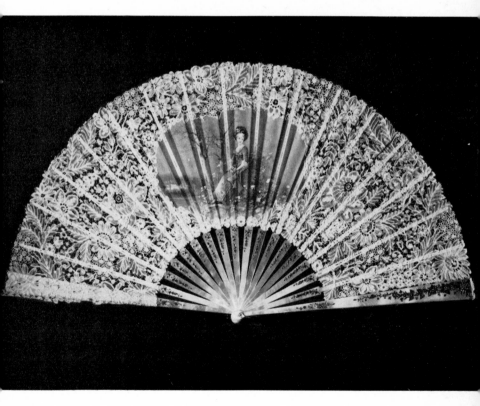

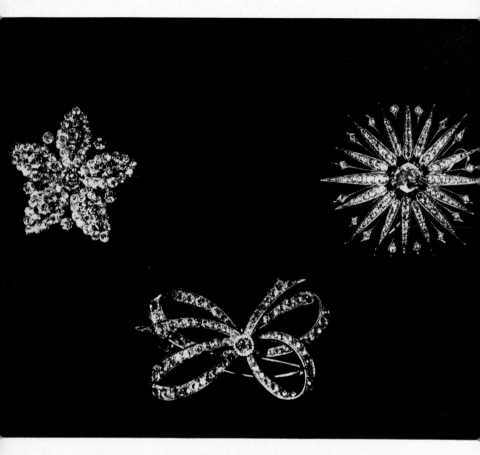

PLATE 145 Three mid-Victorian paste brooches. Paste became very
popular in jewellery as it was naturally cheaper than precious
or semi-precious stones, being made of glass, usually containing
a proportion of lead oxide, and cut to resemble gemstones.

JEWELLERY

The Victorians were fond of jewellery and wore a great deal of it. The Queen herself set the example; on state occasions she was ablaze with jewels, and even in less formal attire wore necklaces, brooches and jewelled bracelets. That curious abnegation of display by men which has never been fully explained by the social historians but which became more and more marked as the century wore on, meant that the principle of vicarious ostentation was established; a man's prosperity was notified to the world by the splendour of his wife's attire. The rising *bourgeoisie* entered into this contest with zest.

It is an old saying and a true one that if a craftsman wishes his work to be preserved for posterity he should avoid using materials which are precious in themselves. Where are the silver lamps of Ghirlandaio and the masterpieces which Benvenuto Cellini wrought in gold ? The answer, alas, is: melted down, long ago.

Much of the finest Victorian jewellery has vanished in this way for, while it was out of fashion, the gold of which it was made was too valuable not to be used again, and precious stones tend to be reset in every generation. Fortunately the Victorians used many materials not costly in themselves, and since there is less temptation to break up a bracelet of garnets than a bracelet of diamonds and a cameo brooch has no intrinsic value, many of

these have survived, although they now realize much higher prices than when a few enlightened collectors first began to seek them out. It is still possible to find examples of what has been called secondary jewellery where paste takes the place of diamonds and chrysalites are used instead of emeralds. There was extensive use of comparatively cheap materials such as coral, jet and ivory.

After the Queen had decided to spend much of her time at Balmoral there was a perfect rage for the crystals known as cairngorms (because so many of them were found in the mountain range of that name). They were the traditional ornaments of the Highlander's dirk, and they now appealed to the English in the form of miniature buckles, with the stones set in silver and used as brooches. Celtic folk-art was also represented by means of reproductions of ancient Irish *fibulae*, and there was for a time a fashion for ornaments made of bog-oak.

Another large category belongs to what may be called the jewellery of sentiment. Lockets containing a miniature portrait on one side and a lock of hair under a glass panel on the other became extremely popular, although the miniatures were not quite of such fine quality as they had been in the eighteenth century. Sometimes the miniatures were used alone; the Queen had a bracelet consisting of linked portraits of all her children, and in those days of universal large families it was easy for her subjects to follow suit.

An important sub-division of this category was mourning jewellery. Most Victorian ladies were in mourning for somebody for a considerable part of their lives and this explains the enormous number of jet ornaments: necklaces, ear-rings, bracelets and brooches that have survived. There was a flourishing industry at Whitby to supply this demand. The shapes and sizes of such ornaments followed the Early Victorian pattern; that is to say, they tended to be large and heavy.

In the second half of the reign there was a reaction, prompted first by the Pre-Raphaelites and taken up by their successors, the

Aesthetes. The new style was plainer and lighter: plain gold bangles and strings of amber beads. These tendencies came to fruition in the Art Nouveau style of the end of the century, the products of which had a curious amateur look (in comparison with the highly professional workmanship of the earlier period): patches of enamel set in plaques of hand-beaten silver. But the full development of this style is outside the scope of the present study.

PLATE 146 Bohemian garnet bracelet of about 1880. One of the favourites of Victorian jewellers, the profusion of rich red garnets on necklaces or bracelets achieved a strikingly beautiful and colourful effect.

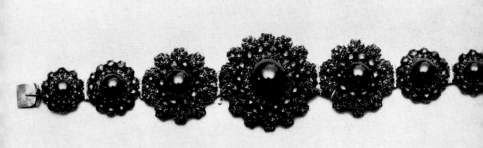

PLATE 147 Locket and chain of engraved silver made in 1882, and ▶
an engraved silver bangle in the form of a belt and buckle. Widely
used as a setting for precious stones in the eighteenth century,
silver declined in popularity during the Victorian era, as
it tarnished quickly in the smoky atmosphere of the new cities.

PLATE 148 A collection of Celtic jewellery. On the right, a
silver-mounted agate brooch set with citrines. In the centre,
a *skean dhu* of bog oak and silver, which the fashion for things
Scottish, after the Queen's example, made a popular possession.
On the left, two brooches of agate set in silver, one a replica
of a dirk, and the other, with a heart engraved in the silver,
▼ probably representing the virtues Faith, Hope and Charity.

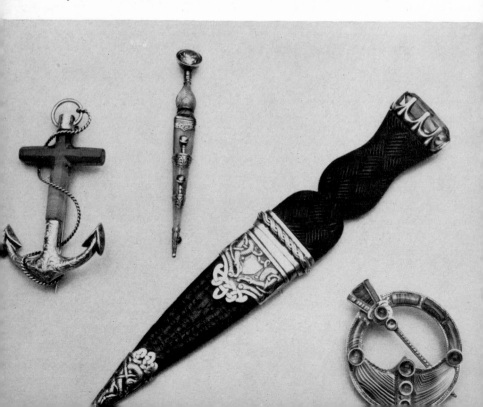

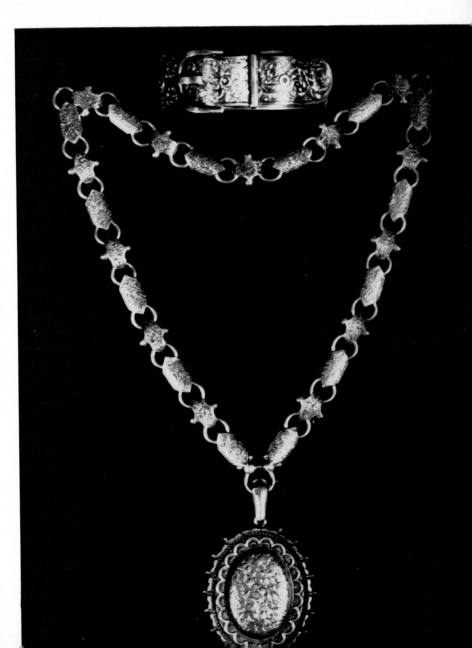

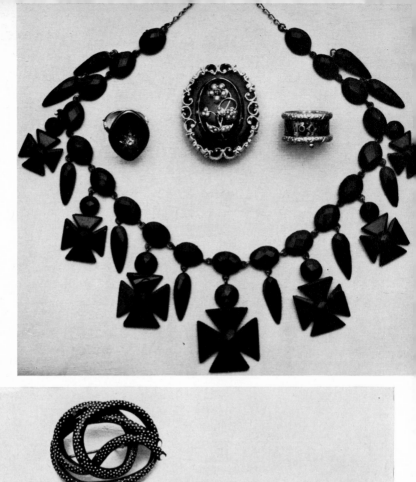

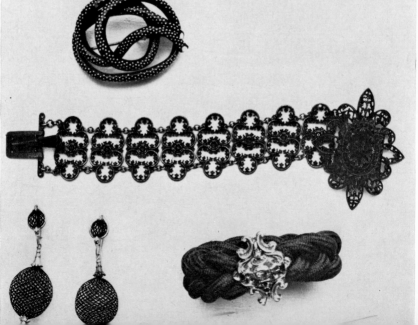

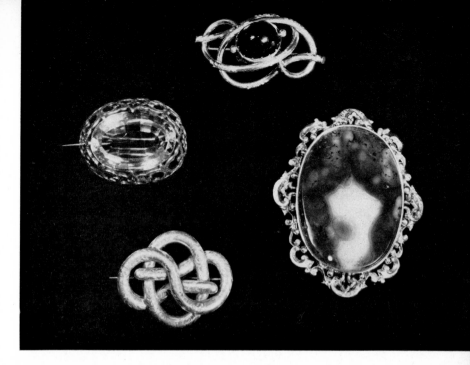

PLATE 149 A selection of Victorian brooches. Top, a paste garnet ▲
set in a knot brooch of pinchbeck; and below it a knot brooch in
engraved silver. Right, an agate brooch set in die-stamped gold;
and left, a Scottish citrine brooch in a pierced silver setting.

◀ PLATES 150 & 151 Examples of Victorian mourning jewellery. At
the top, a necklace in "French Jet", the name used for the black
glass used to imitate jet; a pearl brooch in a black enamel and
gold setting; and two mourning rings in black enamel and gold.
Below, a bracelet in Berlin cast-iron; a tortoiseshell brooch
inlaid with gold; and a bracelet and ear-rings made of hair,
probably the hair of the departed, a strange and rather morbid
by-product of the Victorian taste for momentos of the dead.

V—K

PLATE 152 A stone-cameo brooch in agate, of
about 1850; and two shell-cameo bracelets in
reddish and yellowish pinchbeck of about 1860.
Pinchbeck is an alloy of copper and zinc used
in jewellery to simulate gold, invented by
a watchmaker, Christopher Pinchbeck, in the
early eighteenth century.

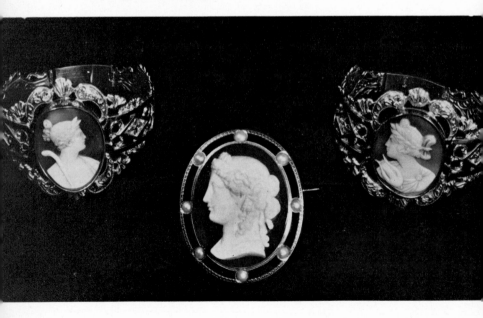

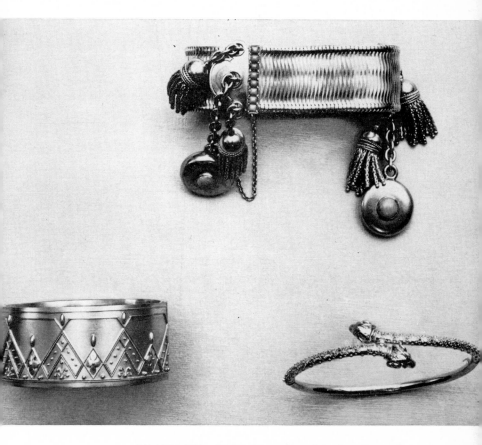

PLATE 153 Living in an age of exploration and
discovery, Victorian jewellers were influenced
by the widening world around them, and Grecian,
Etruscan, and Egyptian styles were copied and
intermingled. This trend is apparent in the
gold bangles illustrated here; the one at the
top is flexible, and has pendant lockets.

▲ PLATE 154 Continental pendant brooch in the Art Nouveau style. The ivory face has eyes made of opal and is set with garnets.

PLATE 155 Late nineteenth century amber necklace, cut in a style suitable for "aesthetic" ladies.

▶

PLATE 156 Swiss enamel plaque and bracelet, late nineteenth century.

▼

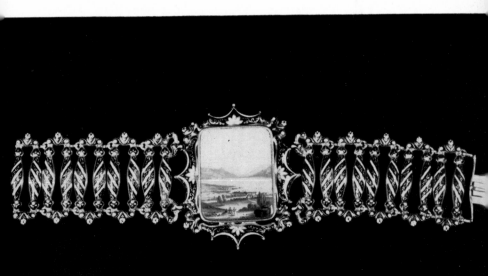

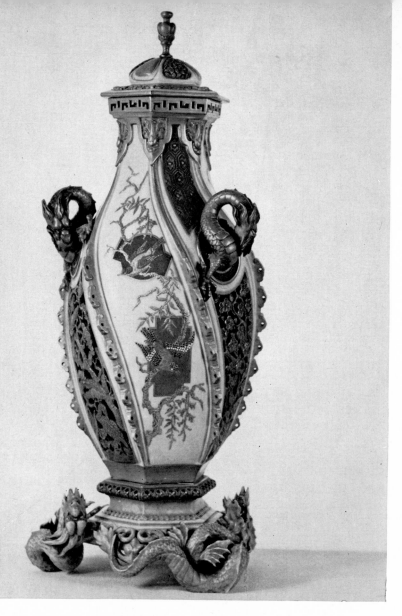

PLATE 157 Royal Worcester covered vase in the "Japanese" style, decorated in metals on an ivory ground, and made about 1880. It was modelled by James Hadley (1837–1903), whose work, together with the gilding of the Callowhill brothers, made Worcesters the leading manufacturers of this ware.

POTTERY AND
PORCELAIN

There was an immense output of pottery and porcelain during the Victorian era, but certain items stand out as most typical of the sentiment of the period. Chief among these, perhaps, are the "Staffordshire figures". They were never intended for the drawing-rooms of the wealthy, but rather for the cottage kitchen or bedroom and their natural place was on the chimney-piece.

The ceramic figures made in the eighteenth century were mostly of porcelain which lent itself to every refinement of detail, but by the beginning of Victoria's reign the makers were aiming at a more popular market, and were using earthenware for the much simplified forms of their products. The simplest and easiest to turn out were the dogs, and this accounts for the comparatively large numbers that have survived.

Vying in popularity with these were the miniature cottages and castles surrounded by vegetation in what is called "shredded clay". Some of these were designed as pastille burners, the smoke emerging in convincing fashion from the tiny chimney, but the need for pastille burning gradually grew less as sanitation improved.

Most of the figures were "flat-backs"; that is to say, they had no moulding on the side turned away from the spectator. Ruskin would not have approved of this, but no doubt it saved a great deal of trouble and expense. There were, however, some

fully modelled figures. These could represent famous contemporary personalities such as Jenny Lind or Mrs. Bloomer, Sir John Franklin, Napoleon III or Garibaldi; and British Royalty was by no means forgotten. The earliest figure of Queen Victoria was offered to the public in the very year of her accession. When the Queen took over Balmoral there was a rage for all things Scottish and we find innumerable figures in Highland dress. The Crimean War and the Indian Mutiny produced a whole crop of heroes, and other popular figures of a slightly later period represented the well-known evangelists Moody and Sankey. An amusing item very popular with American collectors is a figure indubitably representing Benjamin Franklin but plainly inscribed "George Washington". An interesting sidelight on the Liberal and Nonconformist (i.e. lower middle class) market which was aimed at is provided by Thomas Balston in his "Staffordshire Portrait Figures of the Victorian Age". He points out that famous Nonconformist preachers far outnumber the clergy of the Established or the Roman Catholic Church and that only Disraeli, among politicians, represents the "Right".

In addition to Staffordshire figures, most Victorian cottage parlours displayed a number of decorative jugs. Most of these were of stoneware with figures in fairly sharp relief. The scenes represented ranged from Bacchanalian revels to Biblical characters such as the Infant Samuel. The Toby jug, which originated in the eighteenth century, continued to be produced, with some coarsening of modelling, until the end of the nineteenth. There was also a vogue for a revived form of majolica, based on Renaissance originals.

It was not only the cottagers who thought that no chimney-piece was complete without a pair of ceramic objects, preferably decorative vases. The drawing-rooms of the new large town houses in Kensington and Belgravia provided a ready market for Coalport Sèvres and imitations of other eighteenth century styles, as well as for vases with scenic panels containing romantic landscapes, birds, flowers and fruit. Some ambitious examples

were shown at the Great Exhibition of 1851 by Copeland, Minton and the Derby factory. The technical accomplishment of these was remarkable and many specimens have found their rightful place in museums. They have not, however, shared in the modern collecting boom in Victoriana.

Something must be said of the "white parian" or "statuary porcelain" figures, which are one of the most characteristic products of the age. The idea was to imitate marble; indeed, "to reduce some fine statues to a convenient size", as was stated in a report of the Art Union of London in 1845. Copeland and Garrett of Stoke-on-Trent were the pioneers and their first product was a miniature reproduction of John Gibson's "Narcissus". Other manufacturers followed, notably Minton, who not only produced miniature "classical statues", but Biblical scenes and characters from Shakespeare. As many moulds were required the work was of some delicacy and the "parian" figures could never be produced as cheaply as Staffordshire pottery. They took their place in the prosperous drawing-room, usually under a glass shade. Some examples were polychrome, but most parian figures aimed at what the Victorians mistakenly believed to be the pure white of classical statues.

The last quarter of the century saw the rise of what was called "art pottery", a reflection of the Arts and Crafts movement inspired by William Morris. The most influential "art" potter was William De Morgan with his revival of lustre colours. His decorative tiles, made from his own designs, were the delight of the Aesthetes. Other art potters reflected the Japanese influences of the 1870s and 'eighties, and already a hint of what was to be called Art Nouveau.

PLATE 158 Porcelain vase painted and gilt, the stand with four crouching boys in unglazed porcelain after a model by A. Carrier de Belleuse. Made at the Minton factory, and exhibited at the International Exhibition of 1862 in London.

▶

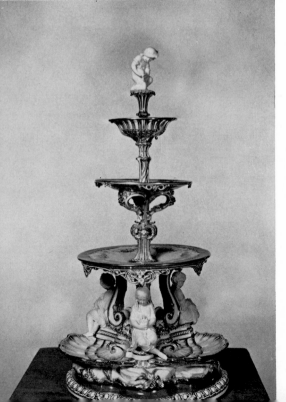

PLATE 159 Centrepiece in parian and glazed porcelain painted and gilt. Made by Minton and designed by E. Jeannest (1813–1857). A duplicate of the dessert service produced for the Great Exhibition and presented by Queen Victoria to the Emperor of Austria.

◀

PLATE 160 "Jewelled porcelain" dessert plate in pierced bone china made by Copelands, about 1889. The figure subjects in period costume were hand painted by Samuel Alcock. The painting is framed by a band of turquoise blue and a raised gold barrier. The pierced rim is richly encrusted with jewelling in turquoise, white and gold.

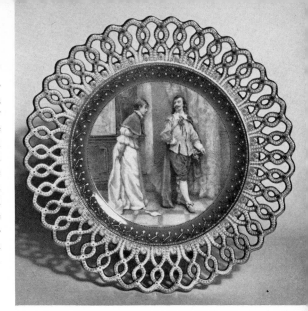

PLATE 161 Coalport porcelain dish in the Sèvres style painted by John Randall (1810–1910). The dish has a turquoise ground and fine quality tooled gilding. So successful were Randall's copies of Sèvres porcelain, that his managing director bought a piece of it and returned it to Randall at the factory to copy.

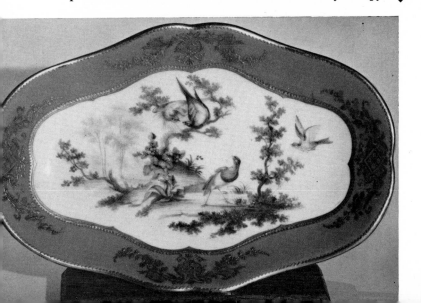

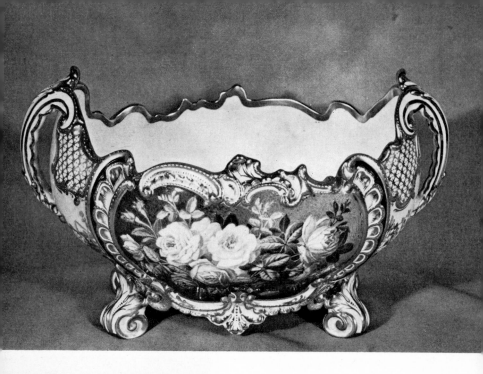

PLATE 162 Comport in bone china made ▲
by Copelands, about 1862. Heavily
modelled in an encrusted style, and
with two panels painted by C. F. Hürten
(1818–1901), probably the finest flower
painter of his day. His studies were
taken direct from nature or from
gouache drawings of his own.

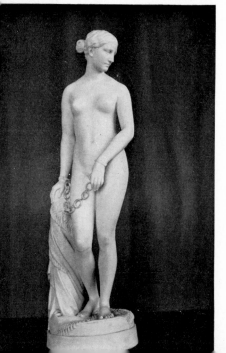

PLATE 163 *The Greek Slave* by the
American sculptor Hiram Powers (1805–
1873). This statuette in the statuary
porcelain known as ''Parian'', made at
Copelands, about 1880, is a replica
of the sculpture executed in 1843
which established Powers's reputation.

◀

PLATE 164 Royal Worcester patera of 1867 decorated in the "Limoges enamel" style on an underglaze blue ground by Thomas Bott (1829–1870), the chief exponent of this style, which was suggested by the painted enamel work on copper which was carried out at Limoges during the Renaissance. ▼

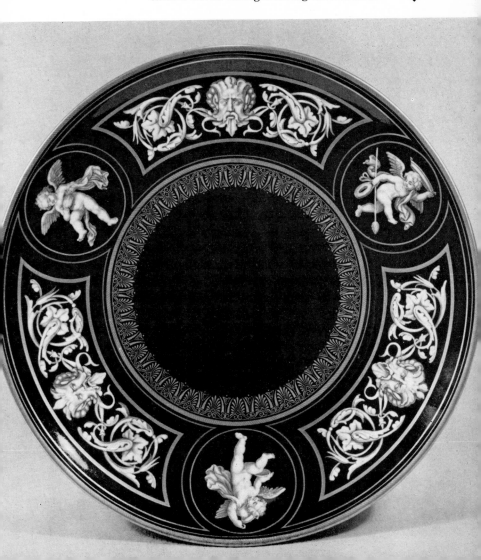

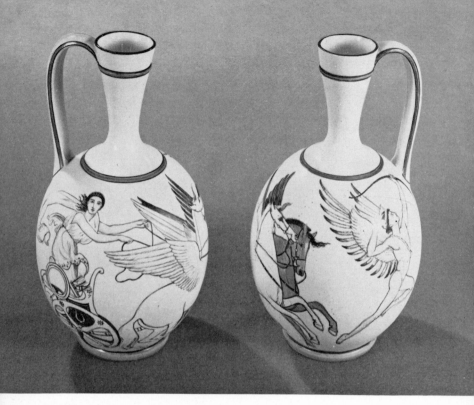

PLATE 165 Pair of vases made at the
Wedgwood factory and decorated with an Art
Nouveau design by Walter Crane.

▲

▶

PLATE 167 Plate in Staffordshire pottery of
about 1870, decorated with holly leaves and
berries. Intended to hold the flaming
raisins and almonds for the snap-dragon
Christmas game depicted in plate 114.

158

PLATE 166 Pottery plate of Bishop Bonner, about 1851; and two ▲
plaques – Adam Clarke, about 1840, and Peace and Plenty about 1851.

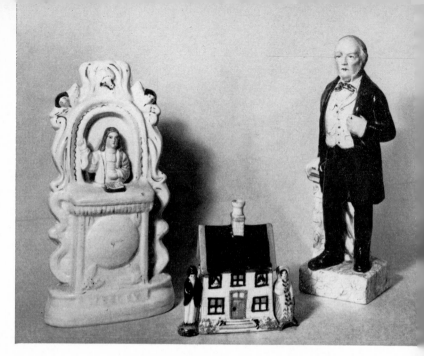

▲ PLATE 168 Flat-backed Staffordshire pottery figure of John Wesley in the pulpit. Staffordshire figure of W. E. Gladstone. Money-box in the form of a house, in Staffordshire pottery.

PLATE 169 Staffordshire pottery figure of Garibaldi with his horse, probably made at the time of his visit to England in 1864, when he received a tumultuous welcome from the public.

▶

PLATE 170 Stoneware jug moulded in relief with a scene from ▲
Nicholas Poussin's painting *Bacchanalian Dance*. Made by Charles
Meigh at Hanley in 1844. The decoration of a mug with the same
scene won him a Society of Arts medal in 1847.

PLATE 171 Two example[s]
Doulton's Lambeth Stonew[are]
On the left, a salt-gla[zed]
stoneware jug in green [and]
blue on a light blue ba[ck]
ground, designed by Art[hur]
B. Barlow in 1873. On [the]
right a salt-glazed sto[ne]
ware vase decorated v[ith]
lilac flowers and foli[age]
on a rust-coloured ba[ck]
ground, designed by M[ark]
V. Marshall, about 18[

◀

PLATE 172 Stoneware vase
and cover, modelled in
relief, painted and gilt.
The decoration includes on
opposite sides a portrait
of Queen Victoria and an
exterior view of the build-
ing for the 1851 Exhibition.
Made by Charles Meigh &
Sons, and exhibited at
the Great Exhibition.

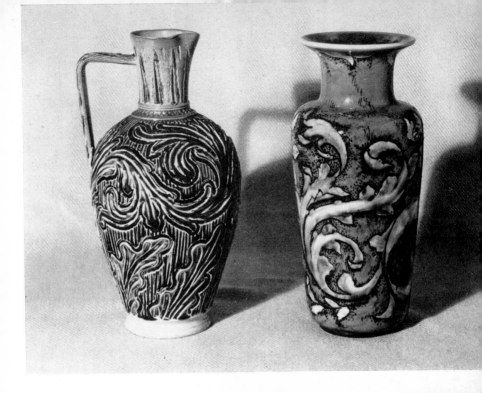

PLATE 173 Tile plaque by
William de Morgan (1839–1917)
made at his Fulham Sands End
Pottery between 1888 and 1898.
De Morgan's work in lustre colours
and ''Persian'' colours on vases,
dishes and tiles received much
praise in the artistic circles
of the late nineteenth century,
but gained him so little money
that in 1905 he turned, success-
fully, to novel writing.

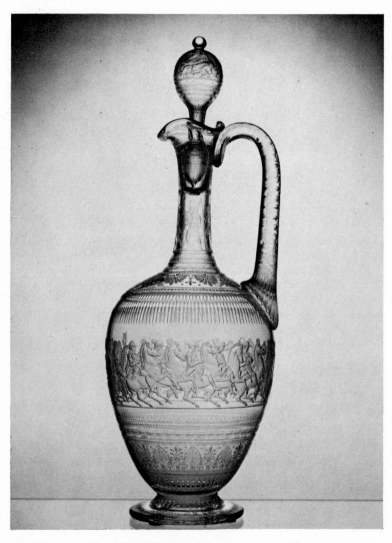

PLATE 174 The "Elgin" claret jug, glass engraved on the wheel by
F. E. Kny at Thomas Webb's Dennis glasshouse, Stourbridge, in 1878.

GLASS

At the height of the vogue for eighteenth-century glass (and it is arguable that English glass making, especially of drinking glasses, reached its highest point during this period) Victorian glassware tended to be neglected. But it had its own qualities and some of the finest examples have already become collector's pieces. Perhaps the most characteristic glass of the period is cut-glass.

Cut-glass has a long history; indeed, examples have been found made during the Roman occupation of Britain, and the method used in modern times is exactly the same as the one described by Pliny in the middle of the first century. There was a revival in England in the reign of Charles I, and a century and a half later cut-glass figured on every fashionable table and no grand house was complete without its cut-glass chandelier. More modest establishments could not afford these, but many an Early Victorian mantelpiece boasted a pair of ornaments with cut-class diggle-daggles. Then in the middle of the reign cut-glass fell out of favour, partly on account of the diatribes of Ruskin, who denounced it in his best apocalyptic style: "The peculiar qualities of glass are ductility when heated, and transparency when cold. . . . All work in glass is bad which does not with loud voice, proclaim one or other of these qualities. Consequently all cut glass is barbarous." After this, there was

nothing for the Aesthetes to do but reject it absolutely.

It is interesting to note that while most of the glass exhibited at the Great Exhibition of 1851 was cut-glass, at the Great Exhibition of 1862 the wares shown included opal vases painted with enamel, and coloured wine glasses. In the following decade a method was discovered of covering colourless or pale ruby table glass and vases with very closely wound glass threading of a different hue. Decanters changed their shape, becoming taller and less firm on their base. We are told that "the necessity for stability decreased" owing to the "change in social habits". This was a polite way of saying that the Victorian gentleman was not usually as intoxicated at the end of dinner as his Regency father.

Part of Ruskin's dislike of cut-glass was perhaps due to the pressed glass imitations, and certainly moulded glass has little aesthetic quality, its only merit being cheapness. And Ruskin's influence inspired the simple tableware designed for William Morris by Philip Webb and made at the London glassworks of James Powell and Sons. These products were handmade blown glass, both clear and coloured, and had considerable influence on the Arts and Crafts Movement.

What is known as cameo glass enjoyed a considerable vogue in the second half of the century, stimulated by the interest in the celebrated Portland Vase. Wedgwood had copied it in porcelain, not in glass like the original. Now, in the 1860s, a more faithful copy was produced after much experiment by Philip Pargeter and John Northwood, and the method he perfected made it possible to make cameos in imitation of those of antiquity. Other manufacturers not only imitated works in the newly-founded South Kensington Museum but produced original items. "Beautiful effects in floral and other designs" were obtained, sometimes by the minute copying of actual flowers and ferns, but it is disconcerting to be told that one of the objects of the process was the "imitation of old carved ivory". The results were not always happy, but the technical

accomplishment of many of the vases and other objects produced by English glass manufacturers in the last quarter of the nineteenth century was truly extraordinary. It is interesting to note that in the very end of this period Röntgen rays (now called X-rays) were employed to detect flaws in the glass before the arduous work of decoration was begun.

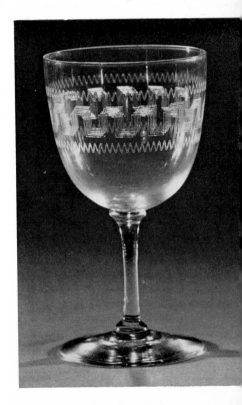

PLATES 175 & 176 Two well-known kinds of Victorian glass. Left, a heavy glass with an engraved leaf pattern, probably a fine example of Victorian pub glass. Right, a key pattern glass, one of the first patterns produced by the "geometrical" etching machine invented by John Northwood about 1865.

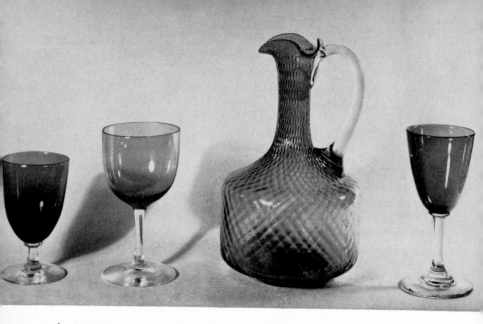

▲ PLATE 177 Three styles of drinking glass and a decanter in the
pinkish coloured glass known as Cranberry.

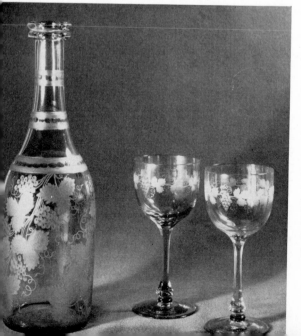

◀

PLATE 178 The Victorians
used a wide variety of
colour in their glass –
Bristol Blue, deep purple and
the yellowy-green known as
Vaseline. Here we have a
light-green coloured decanter
and two wine glasses,
engraved with a design of
grapes and vine leaves.

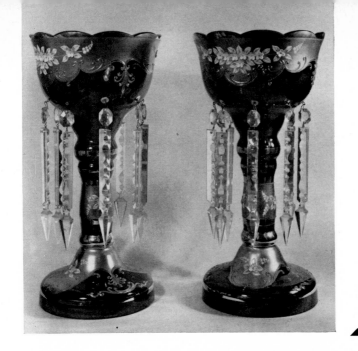

PLATE 179 Two Bristol Blue vases, gilded, with cut-glass lustres.

PLATE 180 Two early Victorian perfume bottles. Left, in gilded Bristol Blue glass. Right, in Vaseline coloured cut-glass.

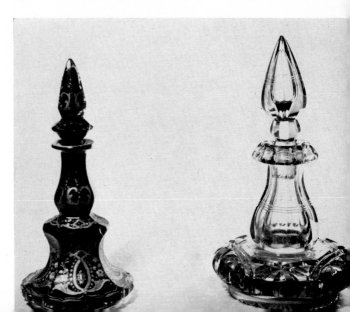

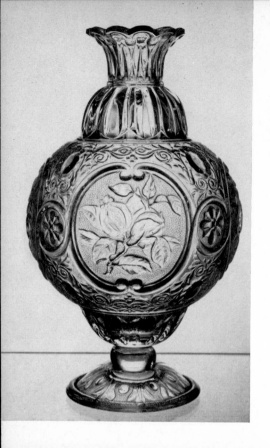

◀

PLATE 181 Glass vase engraved on the wheel by F. E. Kny at the Stourbridge factory of Thomas Webb & Sons, about 1880.

PLATE 182 Two miniature jugs, one with a basin, and a bottle in the milk-white translucent glass known as opaline

▼

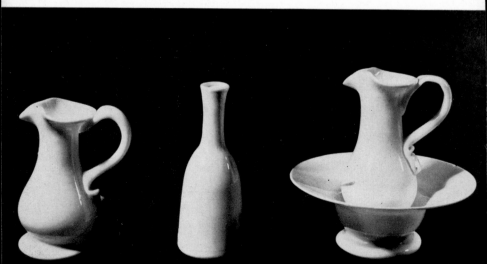

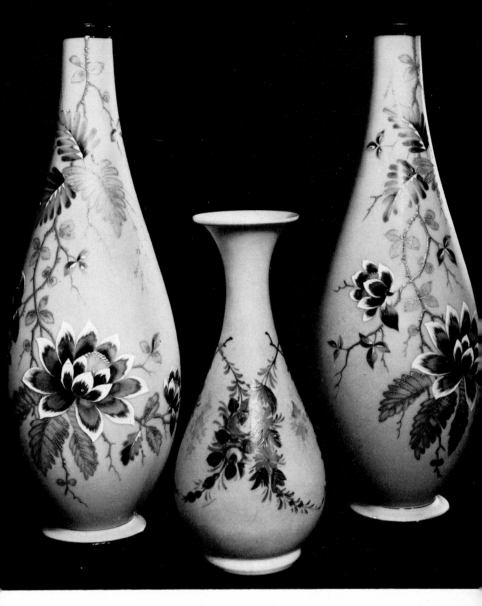

PLATE 183 The manufacture of opaque glass, usually achieved by ▲
the use of oxide of tin, gave opportunity for the decorator,
professional and amateur alike. These three opaque vases have
a painted decoration of leaves and flowers.

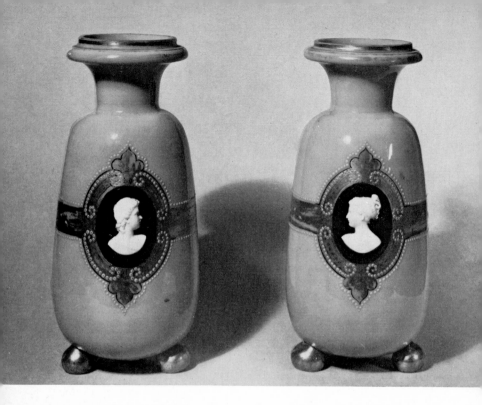

PLATE 184 Semi-opaque
blue glass vases, gilded,
and with Wedgwood
decorative cameo panels.

PLATE 185 Stourbridge
paperweight. These were
usually either made in
millefiori – intricate
geometrical arrangements
of tiny tubes of coloured
glass – or were composed of
flowers embedded in solid
mounds of clear glass, or
had a "scrambled" design.

▶

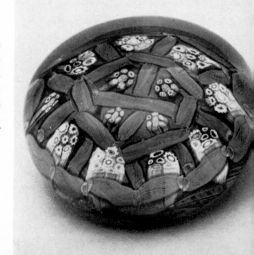

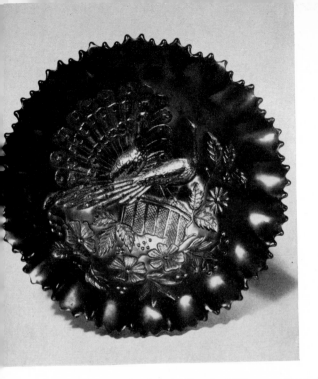

▲ PLATE 186 This plate in Carnival Glass appears almost black itself, but reflects rich coloured lights.

PLATE 187 Bottles decorated with loops of coloured glass, one of many varieties known as "Nailsea". ▼

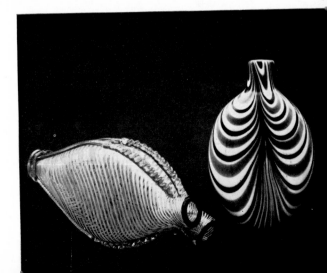

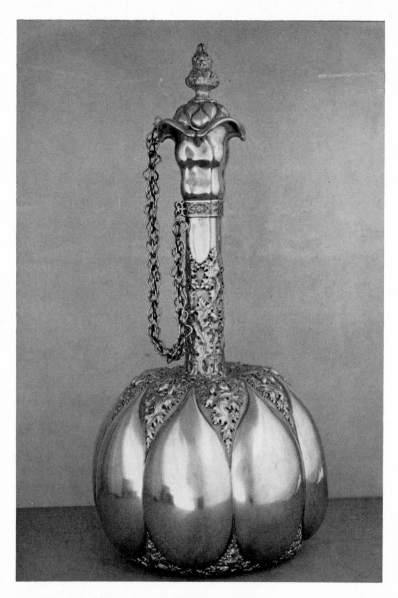

PLATE 188 Silver parcel gilt flagon. Made by
C. T. & G. Fox for Lambert & Rawlings, London,
and exhibited at the Great Exhibition, 1851.

SILVER AND
SILVER-PLATE

Silver has been called the chief status symbol of the Victorian era. It had, of course, been such for a long time, but by 1850 far more people than ever before were able to afford it, and if they could not there was Sheffield plate and, later, electro-plate to fill the gap. For a long time Victorian silver was despised by collectors. "Georgian" silver was preferred and the dealers stretched the word to cover the reign of William IV; but they could hardly stretch it further.

There was no violent break in the shapes of tableware; it was only that the handles of forks and spoons received more decoration in what was rather quaintly thought of as a "rococo" revival. Until recently it was the fashion to sneer at fish knives as an invention of the genteel Victorian suburbs, but research has shown that they were in existence at least as early as 1820 and that some of them have ducal coronets. They were, indeed, a very sensible invention in the days before stainless steel.

In the 1840s and early 'fifties there was a passion for naturalism, plates and dishes being made in the form of leaves and flowers, represented in every detail. Pushing this to its logical conclusion, manufacturers sometimes used real ivy or vine leaves electro-plated. The prevailing romanticism brought in a taste for exotic plants like silver palm trees adorning centre pieces and dessert stands, and after the publication between 1842 and

1845 of Owen Jones's *Details of the Alhambra*, Moorish architectural features were added. An astonishing table fountain in oxydised silver, parcel gilt and enamel, was made in 1852 "under the direction of the Prince Consort". Around an elaborately chased Moorish pavilion were grouped a number of Arab horses, two blackamoors and a dog.

Such table decorations were naturally costly and only to be seen in the houses of the great, but they form part of a whole category of what might be called "display silver". Some of these were testimonials to eminent persons from the Duke of Wellington to some worthy local mayor. Naturalism was the keynote and perhaps the extreme was reached in the Conyers Testimonial presented to a well-known sporting squire in 1851. It shows an oak tree in which a fox has taken refuge; a dismounted huntsman is climbing the tree to dislodge it and Mr. Conyers himself looks on on horseback with whip and reins in silver wire, and assorted hounds below.

With this extreme naturalism went an almost slavish imitation of some of the styles of the past. The Gothic was in general reserved for church plate but one of the 1851 exhibits was of a tea and coffee service of "richly engraved" Gothic design, which is about as sensible a notion as our own "Tudor" petrol stations. Far more craftsmen went back to the early sixteenth century in an attempt to emulate the reputed work of Benvenuto Cellini. The result was a whole series of Renaissance dishes and ewers entirely without use in any Victorian household, however grand. Even comparatively modest establishments, in a misguided passion for "High Art", frequently displayed pretentious objects like Mr. Podsnop's "corpulent, straddling épergne, blotched all over as if it had broken out in an eruption", ridiculed by Dickens in *Our Mutual Friend*. Fortunately most of these monstrosities have long since been melted down.

Already in the 1860s there were signs of a revival of eighteenth century styles and this in the 1880s became the dominant note of domestic silver. "Adam" and "Queen Anne" models were

somewhat slavishly copied, but at least the effect was a little less ponderous than the pieces which had found favour with the previous generation.

Also there was the influence of Japan, increasingly noticeable in all the arts as the Aesthetic Movement got under way. As far as silver was concerned, the Japanese influence was purely a matter of surface decoration, the shapes of the objects remaining European, although occasionally plant-forms such as bamboo were employed three-dimensionally, as they also were in furniture at this period.

A real revolution was inaugurated by a talented designer named Christopher Dresser. He was already making designs for silverware in the 1860s, but his most characteristic work was produced during the two following decades. He preached, and practised, a return to simplicity of form and even made a virtue of economy in the use of his materials; and he insisted that "silver objects . . . should perfectly sense the end for which they have been formed". Some of his designs were happier than others (a silver teapot produced by him in 1879 looks singularly clumsy), but there can be no doubt that his influence was for good and lasted for the rest of the century.

In the 1890s we find the beginnings of the movement which was to bear the name of Art Nouveau, and many of its products with their wilful asymmetry and their swirling convolvulus decoration certainly did not pay much attention to fitness for purpose. It is significant that some of the critics of the day actually praised them for not being "afflicted with that distressing naïveté and 'simplicity' which is the rather easy goal of a certain class of decorators". Fortunately perhaps the full development of Art Nouveau is outside the scope of our present enquiry.

PLATE 189 Silver tea and coffee set of about 1840. The design ▶
is a very well-known one, and those whose families are lucky
enough not to have gone through a period of de-Victorianisation
are likely to find that their Grandmother's set was very similar.

PLATE 190 Fine heavy quality silver salt cellars made in the
form of double shells, each with a cherub posed at the back, and
the interiors of the shells gilt. Made by John S. Hunt, nephew
of the great Regency silversmith Paul Storr, and partner in the
firm of Hunt & Roskell, which was one of the leading exhibitors
▼ at the 1851 Exhibition. This piece was made in 1847.

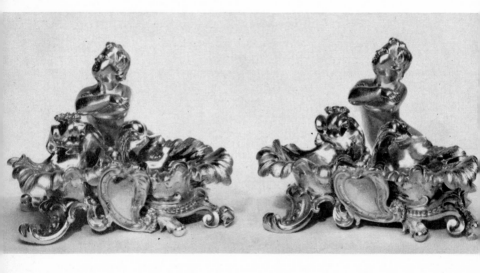

PLATE 191 Elaborately decorated silver tea and coffee service, ▶
made in 1842. The maker's mark is W. H.

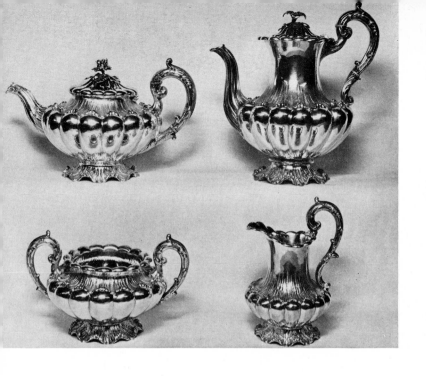

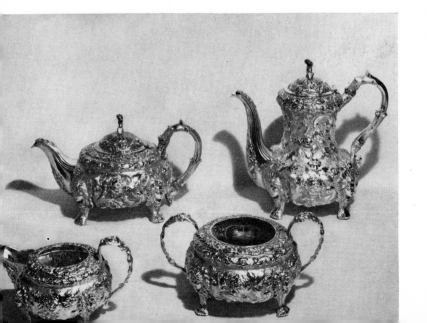

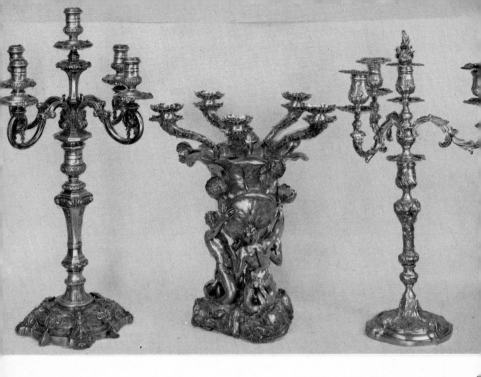

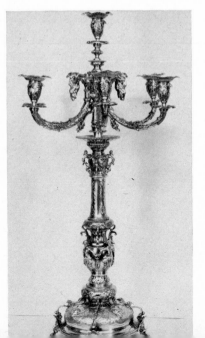

PLATE 192 Silver centre-piece and two silver candelabra, made by Hunt & Roskell in 1849. Candelabra, like the testimonials, gave silversmiths an opportunity to apply every kind of decoration available, and it is rare to find a Victorian candlestick in which every straight line has not been obscured by elaborate foliage or other decorative motifs.

◀

PLATE 193 One of a pair of silver-gilt candelabra made in 1875. The maker's mark is A. M.

PLATE 194 Two from a set of four silver-gilt comports, made in London in 1860. The mercurial method of applying silver-gilt – silver to which a thin layer of gold has been applied, for show or as a protection against tarnishing – was superseded in the nineteenth century by the introduction of electro-gilding. It was the discovery of new methods, like electro-plating, the stepping up of mass production and the discovery of vast new deposits of ore in the United States, Mexico and Australia that brought silver objects within the scope of the whole middle-class. ▼

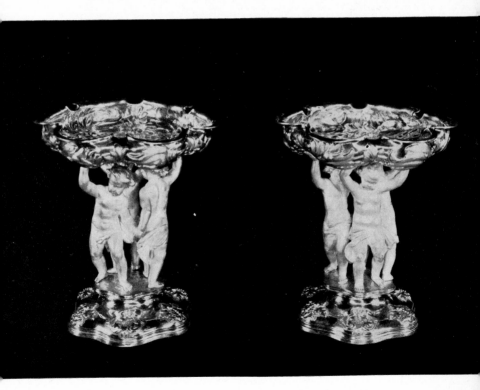

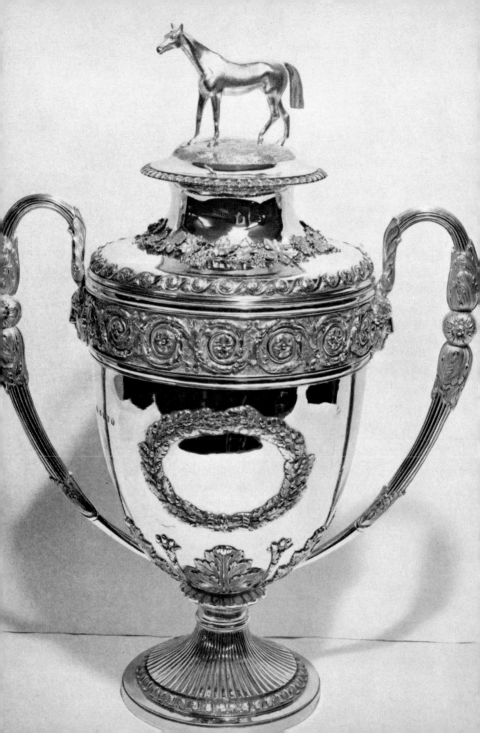

PLATE 195 Silver-gilt cup and cover, made in 1883. A pleasantly restrained version of an object on which Victorian silversmiths usually applied many techniques at one time – frosting, oxidisation, matting, burnishing, parcel gilding – as well as figure decoration. By the 1880s the interest in original design had declined, and the extravagant vulgarity of the 1840s and the angular charm of the 1860s was replaced by a style drawn directly from eighteenth century models.

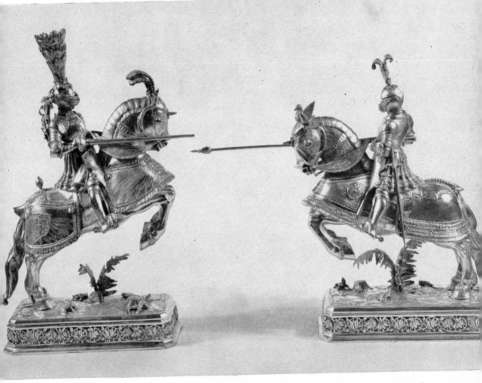

PLATE 196 Pair of charmingly designed silver-gilt knights, made in 1901. While the knights and horses themselves have been modelled in the minutest detail, the stands have been kept as simple as possible, except for a delicate floral pattern.

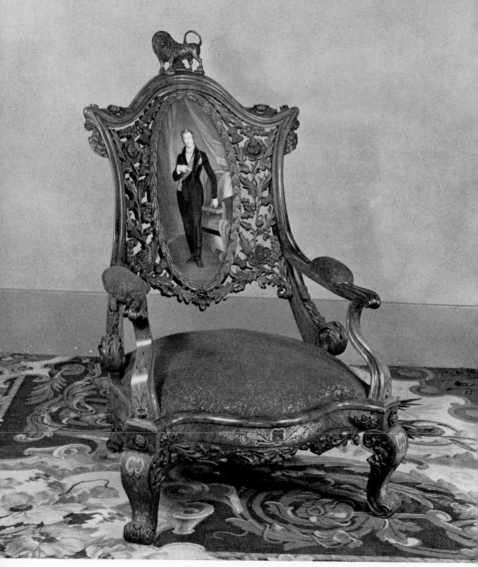

PLATE 197 Carved walnut armchair ornamented with marquetry and set with a Worcester porcelain plaque of Prince Albert. Designed and made by Henry Eyles of Bath for the Great Exhibition. Covered with a profusion of naturalistic ornament, the chair conveys an impression of extreme heaviness disproportionate to its size.

FURNITURE

The long reign of Queen Victoria spanned two generations and if – it is a plausible hypothesis – there is a revolution in taste every thirty years we might expect two such revolutions between 1837 and 1901. And this is roughly what we find. It is, of course, absurd to speak of "Victorian" furniture, except in a general way, for the post-Regency products of the beginning of the reign could hardly differ more than they do from the Art Nouveau products of the turn of the century.

Early Victorian furniture was little more than a coarsening of that of the two previous reigns – it was "Regency" adapted, both in price and construction, to the prosperous *bourgeois* home. It was marked by an extreme solidity and a certain plainness, a relic of the old Puritanism of the middle classes. Unostentatious comfort is the dominant note. There is a strange passion for covering things up, as if it were somehow improper for tables as well as ladies to show their legs. Heavy tablecloths are the rule and over the back of almost every chair is thrown a shawl or an antimacassar. In the bedrooms the old wooden four-poster bed is being replaced by the iron bedstead with brass knobs.

It was in protest against the lack of beauty in the *bourgeois* home and the widening gulf between art and manufacturer due to the rapid industrial development of the early nineteenth

century that the Great Exhibition of 1851 was organised by enlightened men like the Prince Consort. The idea was to stimulate the craftsmen of England by the sight of beautiful objects. Unfortunately the emphasis was almost entirely on the past and on imitations of the past, so that the inevitable result was simply to confirm those tendencies which had been all too obvious since the collapse of the "Empire" style and the revival of the Gothic.

As we turn over the pages of the illustrated catalogue of the Great Exhibition, it is difficult not to be appalled by the monstrosities revealed on almost every page. There are bookcases so bedecked with Gothic pinnacles that there is hardly any space for books; there are sideboards adorned with statues of knights in armour and characters from Sir Walter Scott. Dogs after Landseer gambol over the backs of chairs and form their most uncomfortable arms; stags stand at bay over inkstands, and the towers of Balmoral gleam in mother-of-pearl on the tops of writing desks. There is a riot of ornamentation all derived from the past and all grown heavier and clumsier in the process. Even the great William Morris was not exempt from this romanticism *mal à propos*. There is in the Victoria and Albert Museum a table designed by him which is not only clumsily Gothic in appearance but at which it would be quite impossible to sit without barking the shins.

All this was redolent of the Long Ago; but now a new element entered: a passion for the Far Away. At first this was a good influence, for Whistler, inspired by the Japanese prints which had only just reached Europe, simplified the decoration of his houses, painted his walls yellow, spaced out his narrow-framed pictures and lightened his furniture. He and Rossetti started the vogue for "blue china", and the Aesthetic Movement which followed infected many with the same craze. Liberty's in Regent Street did a roaring trade in oriental wares of all kinds. The result was an outbreak of *japonaiserie* similar to the *chinoiserie* of the eighteenth century; but unfortunately in the nineteenth

there was no dominant European style on which the exotic elements could be grafted. Chinese elements had slipped quite naturally into the framework of the rococo. Japanese elements were so many unassimilated excrescences on the interior decoration of the 'seventies and 'eighties of the nineteenth century. Thus, in Du Maurier's drawings in *Punch* we can note the Japanese screens above the Gothic fireplace; and, mingled with all this, a Pre-Raphaelite picture or a reproduction of a painting by Fra Angelico.

Needless to say, the great public, and especially the *nouveaux riches*, thought the Aesthetic craze merely ridiculous. *Their* ever larger and more lavish drawing-rooms contained no hint of the "greenery-yallery" fever, but were furnished with imitation Louis Quinze furniture, immense Royal Academy canvases in heavy gilt frames and a multitude of palms in pots. The dining-room was enlarged to accommodate twenty or thirty guests and the furnishings were grandiose and garish, as elaborate and heavy as the meals themselves.

At the very end of the century came Art Nouveau. This was originally derived from the Aesthetic Movement which had excited the interest of Continental artists. There were two principal pioneers, Emile Gallé of Nancy and Siegfried Bing, who came from Hamburg but worked in Paris. The dominant decoratif motif was the Egyptian water-lily or the convolvulus. The ornamentation was asymmetrical and every line was curved.

In Germany this was known as Jugend-Stil and Sezession, and in Italy (revealingly enough) as "Liberty", but it was under its French name of Art Nouveau that it returned across the Channel and began to influence English furniture and decoration in the very last years of Victoria's reign.

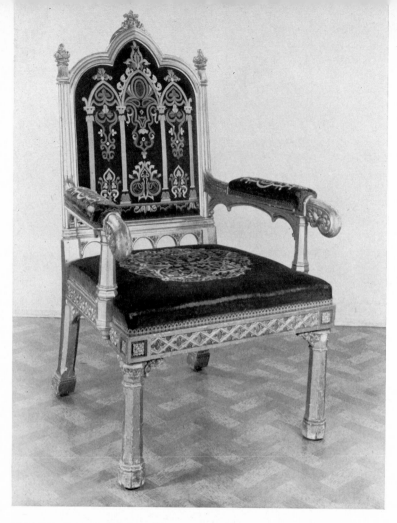

▲ PLATE 198 Gothic armchair of the 1830s, carved and gilded, and
with its original velvet upholstery. An admirably restrained
design in marked contrast to the work of those designers who
made "Gothic" furniture by assembling old pieces of carving.

PLATE 199 Early Victorian chaise-longue, built of wood on an ▶
iron frame, with cabriole legs and upholstered in velvet.

▲ PLATE 200 Two chairs of the mid-Victorian period. One, a balloon-back chair with cabriole legs, is a typical drawing-room chair. The other has cabriole legs and a Berlin wool embroidery seat.

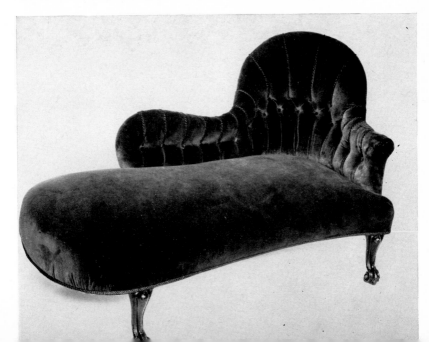

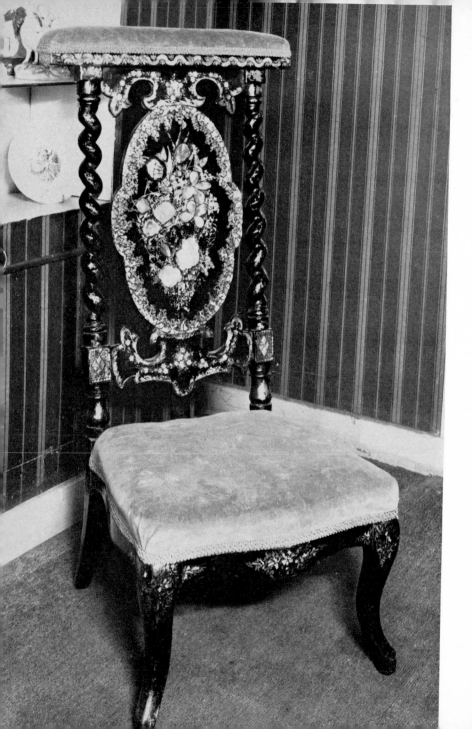

PLATE 201 "Prie-dieu" chair in the Restoration style, with cabriole legs, made of papier-mâché on a wooden framework, painted and inlaid with mother-of-pearl and upholstered in velvet. Made between 1850 and 1855. "Prie-dieu" chairs were often used as a vehicle for the fashionable Berlin woolwork.

PLATE 202 Tray in papier-mâché by Waltons of Wolverhampton, decorated with a fine painting of peacocks and flowers. ▼

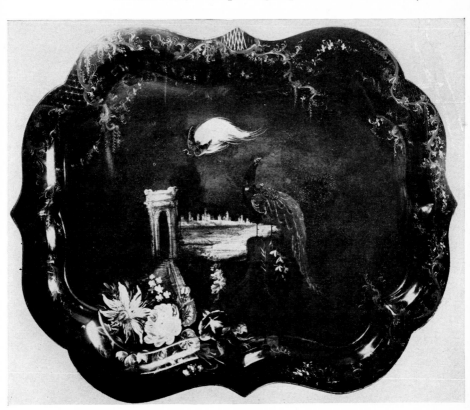

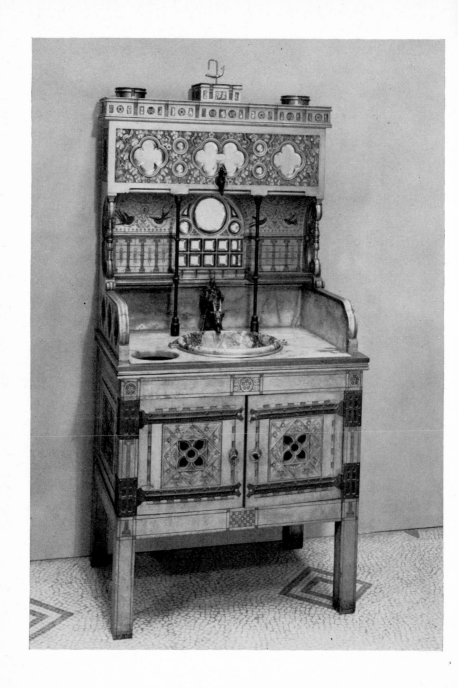

PLATE 203 Cupboard and secretaire in wood painted and gilt, designed by William Burges (1827–1881) in 1858 and made by Harland and Fisher, London. The figure paintings by E. J. Poynter (1836–1919) illustrate the legend of Cadmus, the cutting of Cuneiform letters, Dante and Caxton, and the heads of History, Poetry, Anaxagorus and Pericles. The insides of the cupboard doors are painted with portraits of Poynter and Burges. Remarkable for its simplicity of form in an age of heavy carving, Burges's designs were based on detailed research into medieval work in France and England.

▶

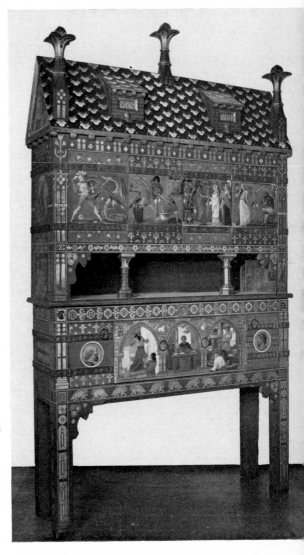

◀ PLATE 204 Carved, painted and gilt wash-stand. The top, bowl and soap-dishes are of marble, and the bowl inset with silver fishes and butterflies. The back and water tank are set with small mirrors, and the taps and fittings are of bronze. Made by William Burges.

PLATE 205 Music Canterbury, made of papier-mâché and inlaid with
mother-of-pearl, about 1860. "Canterbury" is one of many confusing
names not descriptive of use employed by the Victorians, and
▼ is the word used for low ornamental music racks.

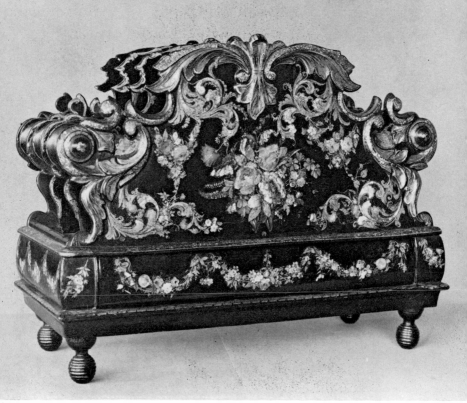

PLATE 206. Workbox and watchstand in sycamore and mahogany, made ▶
by John Solomon, cabinet-maker for Messrs. Trollope, in about 1860.

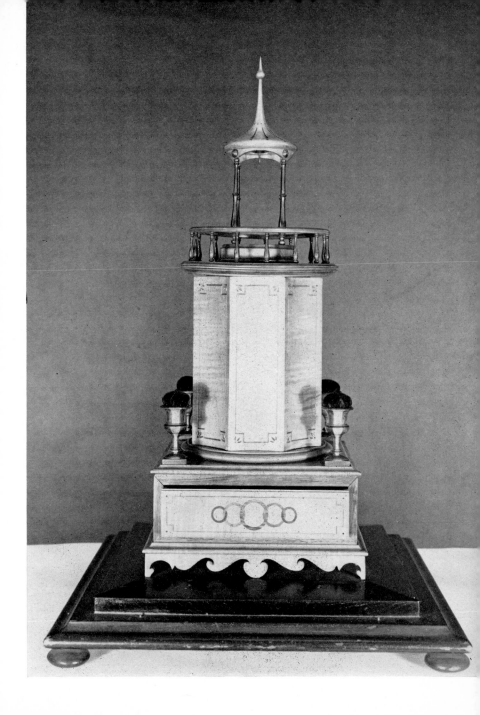

PLATE 207 Sideboard in ebonised wood with silver-plated fittings and inset panels of "embossed leather" paper. Designed by E. W. Godwin (1833–1886) and made by William Watt, about 1867. Beginning in Bristol as an architect in the Gothic style, Godwin came under the influence of Japanese art, and by 1862 he was designing light and elegant pieces, beautifully proportioned, that anticipated the Art Nouveau furnishings of the 'nineties.

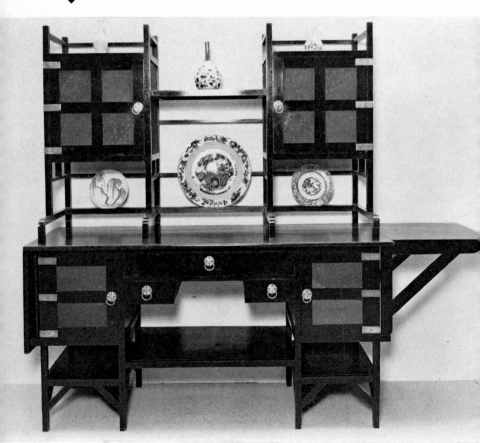

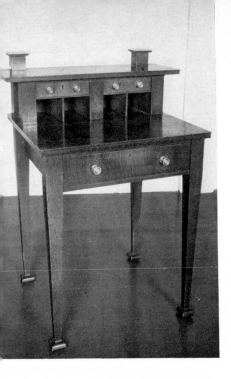

◀

PLATE 208 Oak desk designed by A. H. Mackmurdo (1851–1942) in about 1886. Mackmurdo founded the Century Guild in 1882, a pioneer in the Arts and Crafts movement devoted to encouraging group work in guilds by craftsmen and designers. Its work is characterised by the placing of a classical cornice on the top of almost every piece of furniture, an idea adopted by many of the Art Nouveau designers.

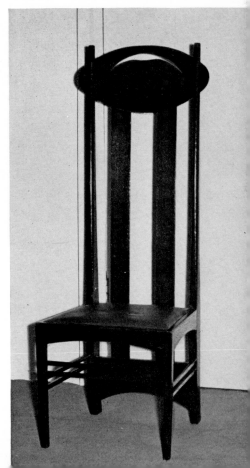

PLATE 209 Oak chair designed by C. R. Mackintosh (1868–1928). Mackintosh was an architect who conceived every work as a unity and therefore set about designing even the smallest detail of a room. His high-backed chairs, for example, though they may appear rather strange in isolation, which is why he and his followers were called the "Spook School" in England, are strikingly elegant within their proper setting, with their restrained ornament and economy of line.

▶

PLATE 210 Multi-coloured machine-
printed wallpaper depicting
the five continents of the world.
Produced in England between
1850 and 1860.

◀
PLATE 211 "Lion and Rose" wall-
paper design by A. W. N. Pugin for
the Houses of Parliament. Hand-
printed by Scott & Co. for
John Crace, about 1848.

PLATE 212 "Daffodil" chintz by ▶
William Morris, 1891, the last
chintz he designed. Hand-block-
printed cotton.

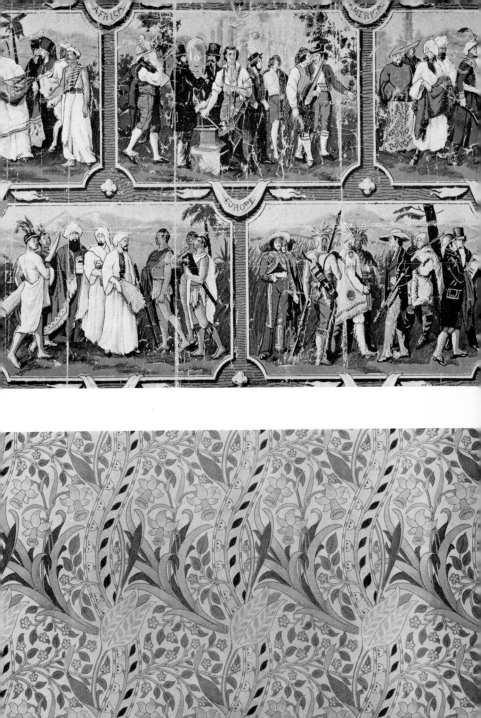

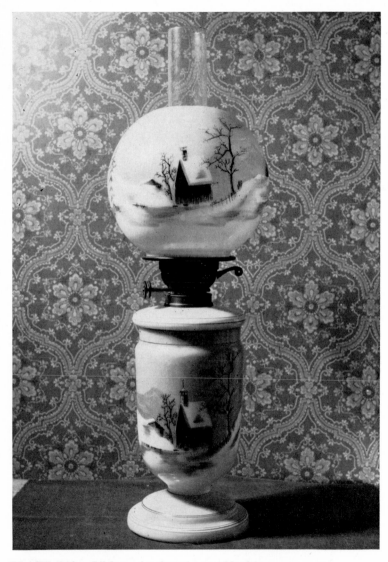

PLATE 213 Oil lamp in glass decorated with a snow scene.
It is probably American, but similar style lamps were
made in this country. The present fashion for using old
lamps with electric fittings in them has damaged many
beautiful examples, but the field is almost inexhaustible.

HOUSEHOLD
FIXTURES
AND FITTINGS

As everybody negotiating the sale or purchase of a house knows only too well, it is sometimes difficult to draw the line exactly between furniture and household fittings. "Fittings", it seems, are not quite the same as "fixtures" in legal parlance, but we can assume for the sake of convenience that a fitting is something fixed. Into this category therefore would come fireplaces and stoves, kitchen ranges, dressers, gasoliers, baths (but those in Early Victorian times were not fixed) and lavatories.

Victorian fireplaces had not the architectural beauty of their eighteenth-century counterparts, many of them being rather clumsy in construction, but the grates set inside them are often attractive. For the most part they were made of cast iron and admirable specimens can sometimes be rescued from demolition contractors. Since wood as a fuel had almost been entirely abandoned in favour of coal, they are often small enough to fit into a modern flat. In shape they follow the prevailing fashion (we are apt to forget how much fashion changed between 1837 and 1901), being rather severe in line in the early years of the Queen's reign, spreading out in the 'fifties and 'sixties as if to ape the shape of the contemporary crinoline, responding to the impulse to make everything gothic and reflecting the Aesthetic enthusiasms of the last quarter of the century.

Stoves never played much part in well-to-do English houses,

**PLATE 214 Print of a bathroom suite
exhibited and awarded a Gold Medal at
the Health Exhibition of 1884.**

and there is nothing comparable with the porcelain masterpieces
of the Teutonic countries. But, of course, every kitchen had its
range, complete with oven and hobs; but these are hardly
collectors' pieces even for the most determined neo-Victorian.
Every kitchen also had its dresser, usually fixed to the wall, and
some surviving specimens have been promoted to modern living-
rooms and painted in gay colours.

Gasoliers (even when equipped with modern electric fittings)
sometimes look very effective, especially if it has been possible
to find enough of the typical spherical glass shades which are
needed to make them look authentic.

There remains the bathroom which, of course, did not exist
as such in Early Victorian days. The usual bath was a hip-bath,
kept in the bedroom and laboriously filled and emptied by the
housemaids. Sometimes the bath was kept in the "back-kitchen"
and certain progressive fathers (as can be seen from the early
numbers of *Punch*) even contrived a primitive shower by means
of a bucket with holes punched in the bottom. The services of
nursemaids and page boys were needed to make this system

effective. Every bedroom, of course, had its washhandstand, complete with bowl, ewer and chamber pot, but such things can hardly be included in household fittings.

The water closet made slow progress. Most houses had an earth closet at the bottom of the garden or at least as far from the house as possible, and many retained these even when water closets had been installed. It is curious to think that there were water closets of a sort in Ancient Egypt and in Crete. Remains of niches supplied with water have been discovered in Pompeii; but the first valve water closet known to history was invented in the reign of Queen Elizabeth. Gradually better ones were devised (300 patents were taken out between 1775 and 1866), but it was not until 1870 that they really became efficient. The early pans were of mustard-coloured stoneware, but these were succeeded by porcelain pans with floral decorations. Searching among the scrap-yards one can sometimes come across such things, magnificent specimens with blue irises growing up from the syphon and dignified by such names as "Pride of the North" or "Caledonian Belle".

PLATE 215 Door lamp-bracket in cast-iron made about 1850.

▲ PLATE 216 Stove in cast bronze and brass with panels of moulded earthenware by Mintons. Designed and modelled by Alfred Stevens and manufactured by Hoole & Co., Sheffield.

PLATE 217 Maughan's gas geyser, made in 1868.

PLATE 218 A free-standing heating stove in polished iron, made in Germany in about 1880.

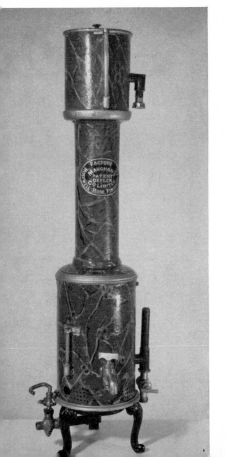

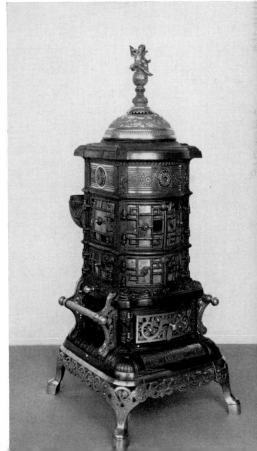

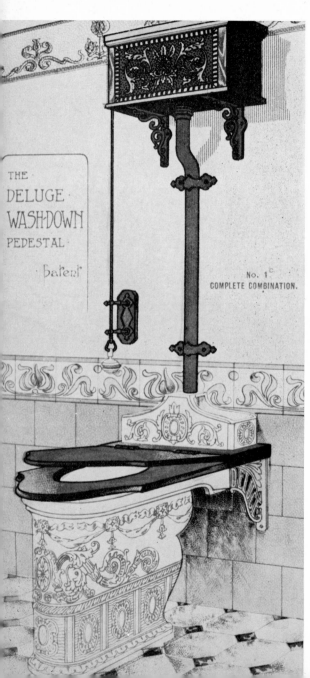

THE
DELUGE
WASH-DOWN
PEDESTAL
patent

No. 1ᶜ
COMPLETE COMBINATION.

PLATE 219 "The Deluge"
patent pedestal, late
Victorian. Decoration
was not confined to the
public rooms in the
Victorian house and lavish
designs were applied to
lavatories just as they
were to chairs and tables.

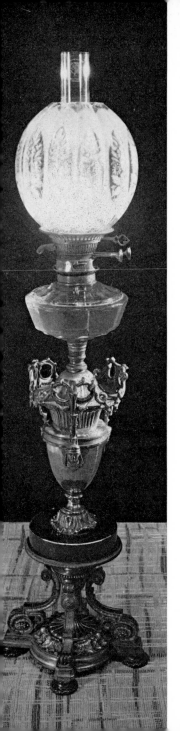

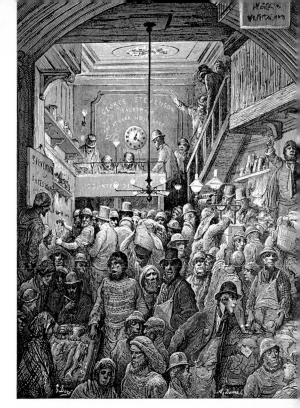

PLATE 220 Gas and oil lighting ▲
in 1872. Billingsgate in the
early morning by Gustave Doré
(1833–1883), the French painter
and book illustrator.

◀

PLATE 221 Excellent example of
a highly decorated Victorian
oil-lamp, this one probably
intended for pride of place in
the drawing-room.

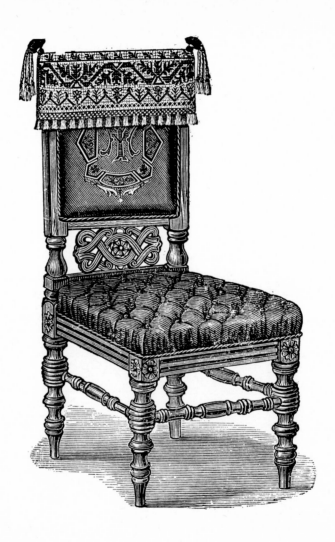

PLATE 222 Chair of walnut wood and dark claret-coloured leather, with monograms worked in claret-coloured silk and gold thread. The antimacassar is worked on garden net with claret-coloured filoselle in cross-stitch, and a fringe of silk.

EMBROIDERY

Many examples of Victorian embroidery have come down to us, and it is obvious that a large proportion of them fall into the category of "Berlin wool-work". It was indeed immensely popular as a home craft requiring, as it did, no more than patience and the faithful following of a pattern. At the beginning of the century a Berlin print-seller had begun issuing squared patterns which could be copied on to a squared canvas, square by square, in a tent-stitch or cross-stitch in coloured worsted wools. These were manufactured at Gotha and dyed in Berlin. As many of the themes were biblical, it was just the thing for the genteel idleness of the Victorian lady and her daughters and they took it up with enthusiasm.

Some of the designs were in the romantic "Troubadour style", some were founded on the paintings of Sir Edwin Landseer, both his ambitious stags at bay and his individual portraits of dogs and cats. Portraits of the Royal Family were also popular, particularly that of the young Prince of Wales in Highland costume. As some of the embroideries were used for covering footstools, some contemporary critics were moved to protest against the unseemliness of treading the Heir to the Throne under foot. It was more suitable, they argued, when the canvases were used for fire-screens, and this indeed is the most characteristic form that has been preserved; but they were

also used for cushions and chairbacks, and for carpets and rugs.

A refinement, especially in pictures of parrots and other exotic birds, was to work the plumage in "plush stitch", cutting the loops to give the effect of a velvet pile. When this was carefully graded it gave the bird an almost three-dimensional appearance. About 1850 there was a craze for the use of glass beads in embroidery, sometimes in combination with wool and sometimes alone. Some of the most charming examples still surviving, especially of footstools, were produced in this manner.

Another favourite product of the period was the patchwork quilt. Some of these quilts were made professionally (for very low wages), but many of them were "ladies' work" and the prosperous household had the advantage of a multitude of scraps of material from old dresses and the like. The earlier examples show geometrical patterns, but in the 1880s there was a vogue for "crazy patchwork", some of them allegedly inspired by Japanese prints.

The same period saw a fashion for "jewelled" embroidery, made possible by new methods of producing imitation jewels. These, together with sequins, fragments of mother-of-pearl, gold wire and passementerie were employed not only as decoration for clothes but to enhance the effect of book covers, pincushions, hair tidies and the like. Those that have survived look a little tawdry and tarnished today, but when they have been carefully preserved they are not without their charm. What have not survived are the traditional embroidered slippers, which every dutiful daughter seems to have delighted in working for the tired feet of the Victorian paterfamilias.

The influence of William Morris led to what might be called "Art School" embroidery, mostly in the "Glasgow Style", of which the principal exponents were the Macdonald sisters and Jessie Newbery. Nearly all the products have a certain Art Nouveau look and, since there is a recent revival of interest in Art Nouveau, may one day be admired. But they basically come into the category of Victoriana.

PLATE 223 Needlework picture of about 1860 in silk, wool and cut steel beads on canvas, depicting a scene from the novel *The Talisman* by Sir Walter Scott.

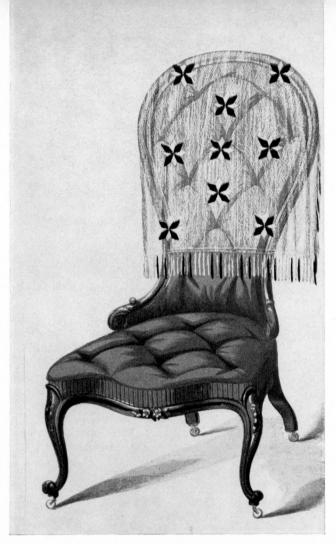

▲ PLATE 224 Netted antimacassar, darned in wool. Berlin wools
were used to decorate many things from samplers to baskets for
bathing dresses, but nothing is more typical of the period
than the antimacassar, designed, like the glass cases over
the clocks, to preserve the furnishings of the middle-class home.

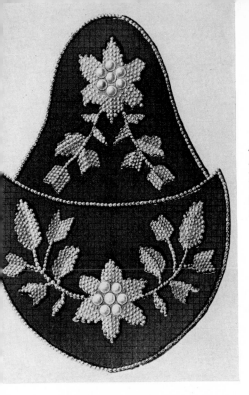

◀

PLATE 225 Watch-pocket
in velvet, decorated with
a pattern in pearl,
crystal and steel beads.

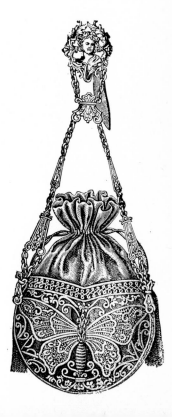

▶

PLATE 226 Aûmonière of pale blue silk
drawn up with cords of the same shade,
the lower part consisting of an
embroidery design in white purse silk.
The bag is fitted with silver chains
and medallion to fix it to the belt.

PLATE 227 Jardinière made of cane and the ▲
panels set with a design in embroidery.

PLATE 228 Screen of black and gold bamboo cane ▶
with an embroidery pattern of leaves and flowers
in coloured silks on a blue ground.

PLATE 229 Smoking-cap in a Greek pattern, ▲
made of brown leather lined with velvet, the
design picked out in gold and silver cord
and decorated with coloured spangles.

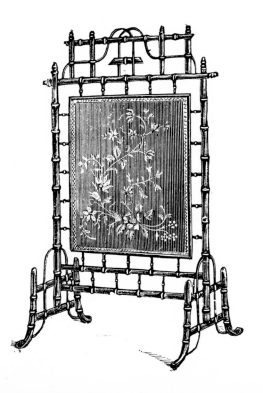

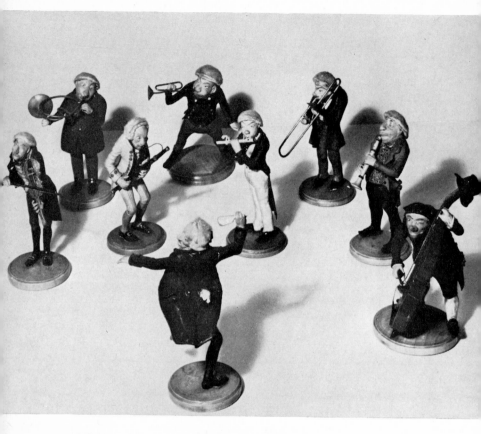

**PLATE 230 Group of eight musicians and a
conductor, constructed of carved wood and
composition and made in Germany in the
early part of the nineteenth century.**

TOYS AND GAMES

There have been toys from the earliest times; the history of games stretches back into remote antiquity and dolls are as old as humanity itself. That so few early examples have survived is due partly to the fact that most of them were made of wood and partly to the natural destructiveness of children. Little animals on wheeled stands have been found in Persia which must date from some eleven hundred years before Christ; a fragment of an alabaster doll with movable arms was discovered in the excavation of ancient Babylon; the Greeks had terracotta dolls with jointed limbs. One should perhaps add that some scholars are of opinion that these were not toys in our sense but votive offerings cast into graves. But in the Middle Ages we are on firmer ground. Although little is known of toys during this period, clay horses, knights and ladies were manufactured at Strasburg as early as the tenth century; and during a recent dredging of the Seine at Paris a whole collection of small objects was found (they must have fallen into the river from the booths which used to stand on the bridges) and among them was a knight on horseback – the earliest "tin soldier" of which we have any record.

We know that there were doll-makers at Nuremberg in the fifteenth century and probably before; and it is curious that until recent times Germany seems to have had a quasi-monopoly of toy manufacture. It is thought that it was the influence of

Luther and the declining market for crucifixes and other objects of piety which led the German woodcarvers of the sixteenth century to turn their attention to toy making. Certain it is that in Victorian times the centre of the industry was still Nuremberg.

With the nineteenth century came mass production, still largely in German hands, and a method of stamping objects out of sheet metal was discovered, which from 1850 onwards made it possible to produce toy soldiers in enormous numbers. There was also a considerable expansion in the sale of mechanical toys, set in motion by clockwork. These also were almost entirely a German (or Swiss) monopoly.

The same is true of dolls, many of which were made by the peasants of the Thuringian Forest. Naturally, they were of wood and were known in England as "Dutch dolls". But during the nineteenth century different materials were adopted: wax, papier-mâché, china and bisque. A method was developed of embedding hair, strand by strand, into the wax with a hot needle. Then came the introduction of glass eyes and, as a final refinement, the "sleeping doll" which, by a system of lead counterweights inside the head, caused the eyes to close when the doll was laid down.

Dolls' houses (also originating in Germany) were known in England in the early eighteenth century. At first they were only to be found in the houses of the aristocracy, but in Victoria's reign they were in every nursery in the land. Some of those surviving provide valuable evidence of interior decoration at this period and for this reason have found their way into museums.

The invention of lithography made it possible to produce cheaply a large number of children's games: lotto, snakes and ladders, sometimes with "improving" mottoes designed to warn children of the dangers of dissipation. Games involving dice were often frowned upon in Evangelical homes, so that a teetotum was used instead. And many pious people objected to ordinary playing cards as "the Devil's picture book". Hence the invention of "Geography Cards", "Happy Families" and the like.

The Great Exhibition of 1851 produced a whole crop of educational games and also those attractive cardboard peepshows, which if not exactly games were certainly toys, and immensely popular. The child's theatre falls into the same category, but is of sufficient importance to warrant separate treatment. The Great Exhibition also stimulated interest in the jigsaw puzzle, usually made of plywood covered with a lithographed sheet coloured by hand. The Victorian child had a larger choice of toys and games than children of any previous period in history.

PLATE 231 Rocking-horse in carved and painted wood. Central and most popular figure in the nursery, the rocking-horse was solidly built and many good examples have survived. This one made in England, early nineteenth century.

PLATE 232 Clockwork automation with musical mechanism, probably
made in Austria. The model opens his mouth, turns his head from
side to side and plucks at his guitar to the rhythm of the music.
There were many varieties of the mechanical toy: clockwork rowing-
boats; clowns joined by rods filled with mercury which caused them
▼ to tumble slowly head over heels down stairs.

PLATE 233 Bisque doll wearing the dress of the St. Marylebone
Charity School. An English production of about 1860. ▼

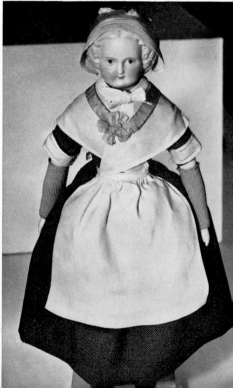

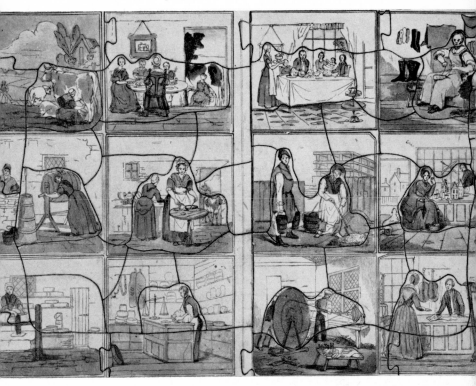

PLATE 234 "Educative" jigsaw puzzle of about ▲
1840. Apparently one of a series entitled
Domestic Animals and their Uses, this one
shows the child the many uses of the cow.
There were many games that had "improving"
purposes behind them, some with unlikely
names like "Vice and Virtue".

221

PLATE 235 Doll's House, of about 1860 to 1865. ▶
English production. Fine doll's houses like
this one attended to the smallest details of
interior decoration, even having miniatures
of kitchen utensils and crockery, and are an
excellent guide to the trends in room design.

PLATE 236 Horse-drawn water cart in carved
and painted wood. An English production of
the late nineteenth century. Those who are
interested in Victorian vehicles would do well
to collect the finely executed models of
▼ carts and carriages, and especially, trains.

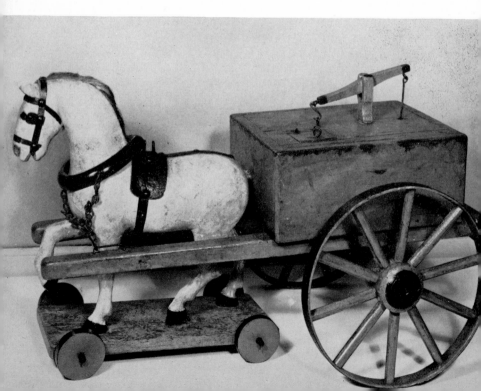

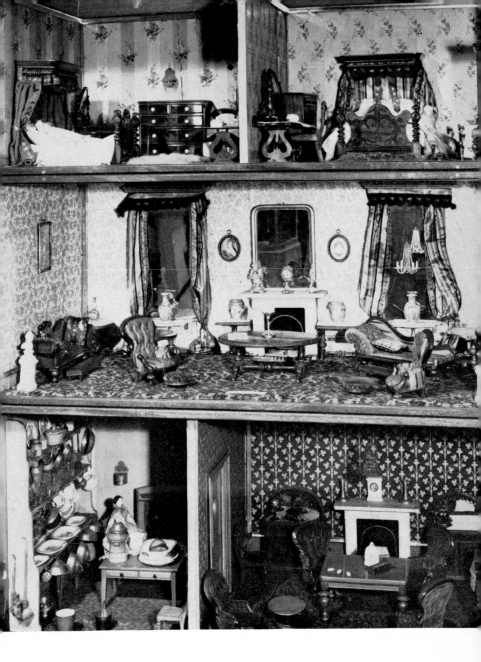

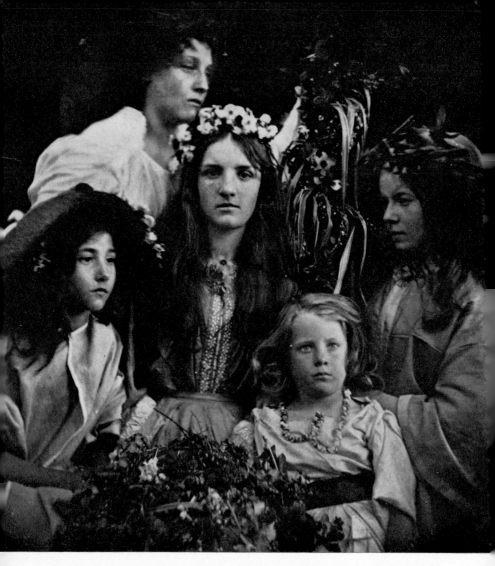

PLATE 237 *May Day* by Julia Margaret Cameron (1815–1879). One of
the early inspired amateurs, Mrs. Cameron's portraits are now
famous for their powerful use of a, then, experimental
technique. Her own dynamic personality seems to have brought
out the best in her sitters, and it is this that must be
responsible for the success of her very personal portraits.

PHOTOGRAPHS

It was but two years after Queen Victoria's accession that Louis Jacques Mandé Daguerre disclosed the process known as daguerreotype. In partnership with J. N. Niepce, he evolved a method of iodising a highly polished silvered copper plate, re-sensitising it with bromide and exposing it in a camera. The results were surprisingly good and soon there were a considerable number of "daguerreian artists" not only in France but in England and America. Meanwhile Fox Talbot was experimenting with sensitised paper and produced what was known as the calotype. The would-be practitioner of the new art needed the skill of a chemist and the patience of a saint. Robert Hunt, "Professor of Mechanical Science in the Museum of Practical Geology", produced in 1851 a *Treatise on the Chemical Changes produced by Solar Radiation and the Production of Pictures from Nature*, containing pages of minute directions for "preparing paper for the camera", exposing it, fixing it and printing it, enough to daunt the courage of any amateur. Some of his recipes have all the sound of a witch's brew, as when he advises us to "beat into a froth the whites of eggs, to which a saturated solution of iodide of potassium and bromide of potassium has been added, in the proportion of thirty drops of the former and two drops of the latter for the white of each egg". One can only marvel that anyone ever took up photography at all. It is interest-

ing to note that the author has an optimistic chapter near the end of his treatise "on the possibility of producing photographs in their natural colours". The world had to wait quite a long time for that.

Scott Archer's development of the wet collodion process was a great advance, but the plate had to be exposed very shortly after its preparation and heavy equipment was necessary. This much limited its usefulness out of doors. Photography remained a highly skilled and complicated business; but in the 1880s the wet plate was succeeded by the dry plate which could be bought ready-made. A large number of amateurs therefore began to "take up" photography. But the cameras remained somewhat clumsy contrivances up to the end of the century and a writer of the 'nineties concluded his directions for taking photographs with the encouraging words: "The apparatus can easily be carried by a man of average strength."

Strangely enough, some of the finest photographs ever taken were produced in the very early days, when it was necessary for anyone sitting for a portrait to remain absolutely still for several minutes. In spite of these difficulties, the photographs taken by the Scottish painter, David Octavius Hill, using Fox Talbot's calotype process, have never been surpassed. A little later came Mrs. Cameron's portraits of Tennyson, Carlyle and other eminent Victorians, which even gained by being, deliberately, slightly out of focus. In landscape, attempts were made to imitate the effects of academic oil-painting, but it is probably not these that the modern collector would wish to acquire.

It is the portraits and portrait groups that are the most redolent of their epoch and the "family album" provides what is in effect a history of costume and manners for the greater part of Victoria's reign.

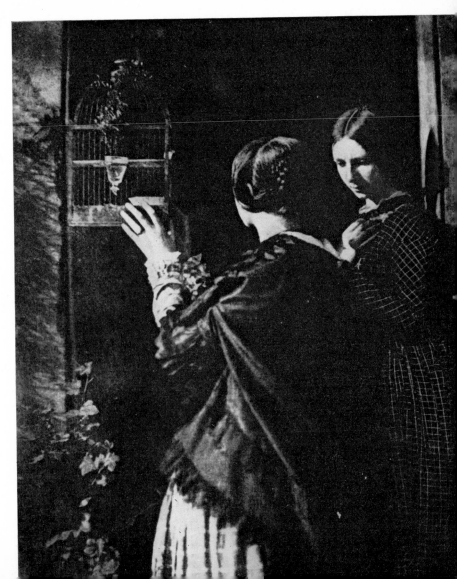

PLATE 239 *Elizabeth Johnstone, the beauty of Newhaven;* a calotype
of 1848 by D. O. Hill and R. Adamson. The calotype, pioneered by
W. H. Fox Talbot (1800–1877), was the first of the negative-
positive processes, its negative being of paper.

PLATE 240 Fleet Street and Ludgate Circus in 1897, thronged with
tradesmen's carts and horse-drawn buses full of city workers.

◀

PLATE 241 *Master Miller:*
a calotype by **D. O. Hill**
and **R. Adamson**, taken in
1848. Though more finely
executed, the pose struck
by the boy is typical
of the stance used in
so many family albums.

▶

PLATE 242 George Combe,
son-in-law of Sarah Siddons:
photographed by **D. O. Hill.**
The success of many of
Hill's photographs is due
to his use of simple masses
of light and shade and
limited detail in the subject.

PLATE 243 *The Angel at the Sepulchre:* a photograph by J. M. Cameron of about 1872. The model in this case was Mrs. Cameron's maid, Mary Hillier, who appears in many of her anecdotal photographs. This example shows how early photographers conceived their works in the same terms as Victorian painters, using them "not merely to amuse, but to instruct, purify and ennoble".

▲ PLATE 244 *So like a shattered column lay the King*, from J. M. Cameron's illustrations to Alfred Tennyson's *The Passing of Arthur*, 1875. Mrs. Cameron's illustrations to Tennyson's *Idylls of the King* and other poems were accompanied by poems or extracts of poems reproduced in the poet's own hand and signed.

PLATE 245 *Paul and Virginia,* by J. M. Cameron. Probably inspired by the eighteenth century French romance entitled *Paul et Virginie* by Bernadin de St. Pierre. The photograph is enhanced by the imperfect focus around the edges, which helps to centre the attention on the faces of the subjects themselves. ▼

PLATE 246 An early photograph of the cyclist Arthur Vivian
Puckle in an heroic pose beside his "penny farthing" cycle.

VARIOUS VEHICLES

No age in history produced a greater variety of vehicles and so many new means of transport as the period from 1837 to 1901, from railways at the beginning to motor-cars at the end. Every kind of "thing of wheels" was produced, but when we speak of Victoriana today we are thinking of examples that can be collected. It would certainly have surprised the Early Victorians to learn that anyone would ever want to "collect" a steam engine or a railway carriage and it is true that such a fancy can only be indulged by a rich man. But there *are* collectors of such things, ugly as they were thought to be when they first appeared. Very soon after Victoria's accession the great days of coaching came to an end. Railways spread with amazing rapidity and put the long-distance coaches out of business. But enthusiasts continued to drive coaches for amusement until the end of the century, and the vehicles used (as, for example, in driving to the Derby) did not differ in essentials (except perhaps, for better brakes) than the professional coaches of the Regency.

The majority of town dwellers could not afford such luxuries. Most of them went about their business or their pleasure on their own two feet, but in cities, especially in large cities, the omnibus played an increasingly important part. It had been introduced from Paris in 1829 and by the beginning of the

Queen's reign there were more than two hundred running in London. Most of them had three horses, inside seats for eleven persons a side and a few extra seats on top. They were painted in striking colours with such names as "Great Western" or "City Atlas" in elaborate script. It is amusing to note that women passengers were precluded from riding on top, except on those buses which were provided with "decency boards" to prevent any fortuitous view of female ankles. The few mid-nineteenth century buses that survive are still in considerable demand from the makers of "period" films.

The more prosperous citizens despised the bus and travelled either in a four-wheeled cab (the "growler" as it was called) or in the two-wheeled hansom. The latter carried only two passengers and it was considered extremely "fast" for any young lady to be seen in one of them.

Trams, which were the invention (paradoxically enough) of an American named Train, were first seen in Birkenhead in 1858, London having refused to allow them. However, in the following year the authorities relented and a line was laid in the Bayswater Road. From then until only the other day, the "People's Carriage" enjoyed increasing popularity and spread all over the world. At first it was pulled by horses, but this method of propulsion was succeeded by steam at the end of the century and later by electricity. Refined people regarded them with distaste and they would certainly have been astonished by the outburst of lamentation which greeted their final disappearance from the London streets.

The Victorian age saw the development of the bicycle. The "hobby horse" of the Regency period had been a crude affair, propelled by the feet on the ground, but in 1839 a Scottish blacksmith designed a machine which could be worked by pedals. Tricycles and quadricycles followed, some of the latter having six seats and being known (reasonably enough) as "Sociables". We are informed, rather ominously, that "only some of the better designs incorporated brakes". In the 'sixties

a French firm developed a bicycle called the vélocipède, later to be known in England as the "bone-shaker".

In the early 'seventies Coventry became a centre of the cycle industry, but curiously enough the machines produced in that decade look much less like modern bicycles than earlier models. The form adopted was the "penny farthing", with one very large and one small wheel. By attaching the pedals to the large wheel it was possible to do away with the necessity for gears, but one needed to be something of an acrobat to work the machine, and it was, of course, "quite unsuitable for ladies". But surviving specimens of the "penny-farthing" would seem to be the most suitable for the modern collector, as there is not much point in buying (or riding) a bicycle which looks very much like a modern machine but is less efficient. The motor-car does not really fall within our period. Specimens from the 'nineties do survive but most of the "old crocks" that still take part in the race to Brighton date from the Edwardian era.

A conspicuous feature of the streets of Victorian cities was the tradesman's cart, often decorated in bright colours and with prominent slogans acting as a perambulating advertisement. All kinds of manually-propelled barrows were to be seen from that of the rag-and-bone man to that of the fruit salesman. Particularly attractive were the milk-carts which, in the south of England, were handcarts of a special splendour, with their vivid paint and gleaming brasswork. Some of these have survived and are sometimes used as items in a reconstructed Victorian décor, or are tethered outside a fish restaurant (why fish ?) which goes in for "period flavour". And Victorian perambulators can occasionally be seen in the more self-conscious residential streets of Chelsea and South Kensington. But alas! the becapped and beribboned nursemaids who once pushed them to the park have vanished from the earth.

PLATE 247 A selection of nine-
teenth century road carriages.
Most often seen in Victorian
city streets were the Broughams,
the Landaus, the Victorias and
the Phaetons, and various
versions of the omnibus.

PLATE 248 Coster cart photo-
graphed in 1877, typical of the
carts used by street-sellers to
carry fruit and vegetables.

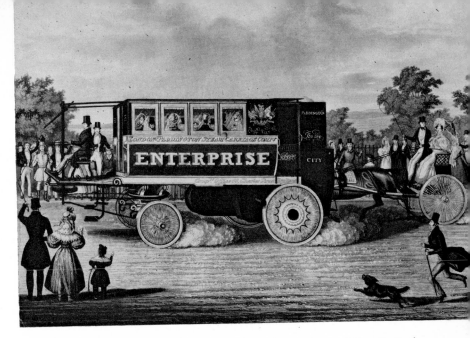

PLATE 249 The Enterprise, built by Walter Hancock of Stratford ▲
for the London and Paddington Steam Carriage Co., which ran
between Paddington and the City from 1833 onwards.

▼ PLATE 250 An English Daimler motor car, built in 1898.

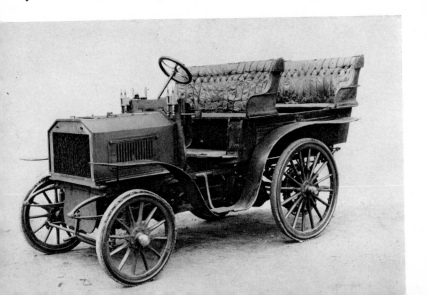

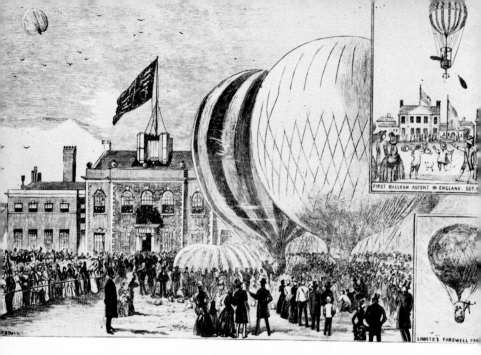

Inside the balloon illustration, text reads: "FIRST BALLOON ASCENT IN ENGLAND. SEP." and "L'HOSTE'S FAREWELL FRO"

PLATE 251 Centenary celebration of the first balloon ascent in ▲ England, held at the Artillery Company's Ground, Finsbury, 1884.

PLATE 252 Interior of a pullman parlour-car on the Midland Railway in 1876. Designers did not differentiate between the ▼ furnishings of first-class travel and those of the drawing-room.

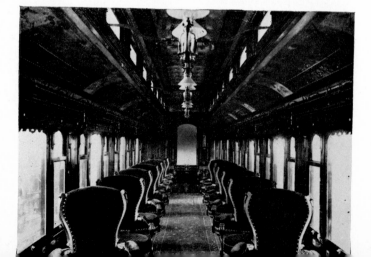

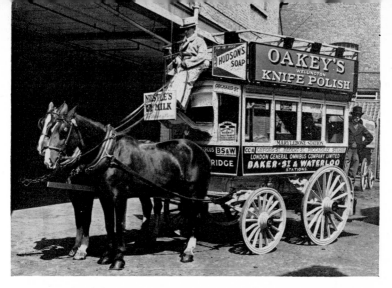

PLATE 253 Horse-bus, for travel between Baker Street and Waterloo. Only the bottom deck was enclosed. ▲

PLATE 254 A water-velocipede, one of the many phenomena produced by an age fascinated with mechanical experiment.

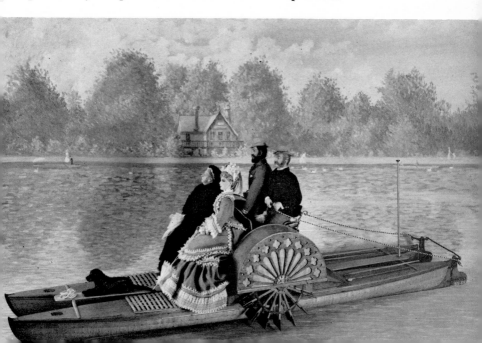

PLATE 255 Cotton flowers in a cane basket under a protective glass case. Thanks to the Victorian passion for preserving decorative items under glass, many of the stuffed birds, wax fruit and sprays of flowers are in excellent condition.

MISCELLANEA

The Victorian era was the very age of the miscellaneous. Never before in human history had so many objects come into being. The Industrial Revolution was essentially a matter of multiplication, bringing innumerable things, which had once been the privilege of the rich, within the reach of nearly everybody. We have tried in the foregoing pages to distribute some of these objects into categories, but much Victoriana simply defies classification. Is the painted horse on a roundabout a vehicle or a piece of sculpture ? Where is one to put a blown-glass ship ?

It is obvious that we must include in Victoriana some things which would never have found a place in a Victorian home. Collectors are beginning to realise, for example, the fascination, and indeed the beauty, of some of the decorations of public houses in the 'seventies and 'eighties. Public house interiors are constantly being transformed into what is known as "neo-Georgian", with the result that many typical pieces are sold or, all too frequently, thrown away.

Engraved glass panels with birds picked out in gold, mirrors painted with storks and bulrushes, the porcelain handles of beer-pumps; all these things could find a place in a sophisticated modern décor. The huge swirling cast-iron supports for lamps outside the public house were frequently to be seen. They have now become extremely rare.

Cast-iron reached its highest point of craftsmanship during the nineteenth century. Railings, balconies, balusters, especially when freshly painted, are full of a delicate exuberance which delights the eye. Victorian street lamps are sometimes saved from reforming municipalities and re-erected in private gardens, and put the modern utilitarian structures to shame.

We have already mentioned roundabout horses. Within recent years there has been quite a craze for some of the more baroque specimens with their elaborate carving and bright colours; even the humbler steed, the nursery rocking horse, has come back into favour and Victorian examples fetch quite high prices in the antique shops. Other roundabout animals such as ostriches, cocks and dragons can sometimes be acquired when a fairground proprietor "goes modern" and installs "Dodgems" or space-ships instead of the traditional prancing figures. Other examples of what Barbara Jones was the first to call the "Unsophisticated Arts" are the painted panels from fair-booths, the cut-out figures from a rifle range, even fair-ground organs. But nowadays it is to the sophisticated that these things appeal.

Of particular interest and beauty are the traditional decorations of canal barges. In these decorations, strangely enough, there is always a castle, "at once English and exotic. Its spreading castellations may suggest Spain, but the bulbous red domes on some of the towers are clearly Russian. . . . The gipsies brought these castles over from Hungary and were the earliest boat people". Other derivations have been suggested, but the fascination and the mystery remains.

Seaside souvenirs form another category of Victorian popular art. It was the great age of "going to the seaside" and every family brought back some trophy of its visit: a glass painting of the promenade in a frame of shells (and some of the frames at least have a curious beauty), painted plates and little models of such dominating features of a resort as the Tower at Blackpool. Sometimes one finds a whole bas-relief constructed of cork.

The Victorians had a passion for putting things under glass

shades. Even clocks were so protected from the carelessness of the dusting housemaid, and, with more justification, blown glass ships, wax fruit, shell-flowers and stuffed birds were similarly enshrined. Some of the stuffed bird displays (the brightest, most exotic birds being usually chosen) were real triumphs of the taxidermist's art. Animals were sometimes displayed in the same way. A big animal like a bear was, of course, not put under glass, but set up in the hall with a tray in front of him to serve as a dumb-waiter.

At Potter's Museum at Bramber, in Sussex, there is a whole collection of stuffed animals dressed up to represent human situations. There are such scenes as "The Death and Burial of Cock Robin", "The Guineapigs' Cricket Match", "The Rabbits' Village School" and "The Kittens' Wedding". The effect is, perhaps, more macabre than pleasing. Only a rather eccentric Victorian would, one feels, have wanted such things in his drawing-room.

Descending from the drawing-room to the kitchen, we would find many things attractive to the modern collectors, particularly, perhaps, those gleaming copper "shapes": jelly and pudding moulds which once formed so important a part of the *batterie de cuisine*. Food-architecture one might call them; part of that passion for display, that almost baroque exuberance which makes every kind of Victorian art-form so different from ours. Perhaps, after all, that is why we want to collect Victoriana.

PLATE 257 French clock of about 1880, with Dresden face and panels. Like the American clock, clocks in this style were very popular in the Victorian home, and were manufactured in France and copied in England for the English market.

PLATES 258 & 259 Many of the Victorian advertisements are charmingly designed, often subtly coloured or using large blocks of colour with great effect. The appeal of children, dressed in grown-up clothes and apparently having mature tastes in kitchen equipment or baking-powder, had already been discovered, as we can see in the American and English advertisements illustrated.

PLATE 260 We have already
seen prominent Victorians
portrayed in sculpture and
pottery, but it seems that
some people even liked to
have their favourite politicians,
like Benjamin Disraeli,
illustrated here,
gazing down from their
wallpaper. This is one of
a set of panels, lithographic
portraits of prominent
Victorians in shades
of sepia, manufactured in
England about 1870 to 1890.

▼

249

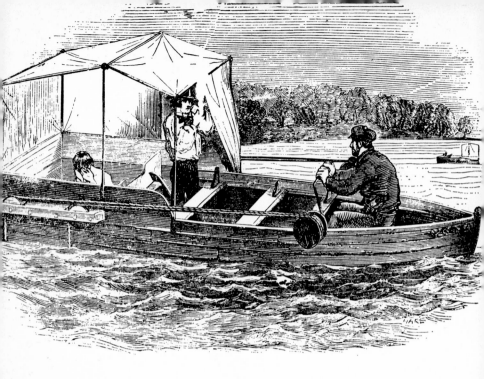

◀

PLATE 261 Gas street
lantern, manufactured in
about 1860. Similar or
more ornate ones can often
be purchased from town
councils when they modern-
ise their street lighting.

◀

PLATE 262 One of the more bizarre products of Victorian
ingenuity was this floating bath designed by Cordingly and shown
on the Serpentine in Hyde Park. From the *Illustrated London News.*

PLATE 263 A selection of wax and glass fruit in a pierced Minton ▲
bowl. Many of the best examples are mounted up among leaves and
foliage and kept safe from dust and domestics behind glass.

BIBLIOGRAPHY

Elizabeth Aslin, *Nineteenth Century English Furniture*, 1962

G. W. Beard, *Nineteenth Century Cameo Glass*, 1956

Anthony Bird, *Early Victorian Furniture*, 1964

Michael Booth, *English Melodrama*, 1965

J. Braund, *Illustrations of Furniture from the Great Exhibition*, 1858

George Buday, *The History of the Christmas Card*, 1954

John E. T. Clark, *Musical Boxes*, 1961

Leslie Daikin, *Children's Toys Throughout the Ages*, 1953

Margaret Flower, *Victorian Jewellery*, 1951

William Gaunt, *The Aesthetic Adventure*, 1945

John Gloag, *Victorian Comfort*, 1961

Geoffrey A. Godden, *Antique China and Glass under £5*, 1966

Geoffrey A. Godden, *British Pottery & Porcelain, 1780–1850*, 1966

Geoffrey A. Godden, *Victorian Porcelain*, 1961

Leslie Gordon, *Peepshow into Paradise: A History of Children's Toys*, 1953

M. Goodwin-Smith, *English Domestic Metalwork*, 1937

Vyvyan Holland, *Hand Coloured Fashion Plates*, 1955

Philip James, *English Book Illustration, 1800–1900*, 1947

David Joel, *The Adventure of British Furniture, 1851–1951*, 1953

Barbara Jones, *The Unsophisticated Arts*, 1951

T. King, *Specimens of Furniture Adapted for Modern Instruction*, c. 1850

James Laver, *Fashion and Fashion Plates*, 1943

James Laver, *Victorian Vista*, 1954

Henry Lawford, *The Cabinet of Practical, Useful and Decorative Furniture Designs*, 1859

Ruth W. Lee, *A History of Valentines*, 1953

G. Felix Lenoir, *Guide to Upholstery*, 1890

Barbara J. Morris, *Victorian Embroidery*, 1962

Herbert Read, *Staffordshire Pottery Figures*, 1929

F. Gordon Roe, *Victorian Furniture*, 1952

R. B. Symonds and B. B. Whineray, *Victorian Furniture*, 1962

B. J. Talbert, *Gothic Forms Applied to Furniture, Metal Work, Etc. for Interior Purposes*, 1867

George J. Thompson, *Book of Designs of Chimney Glasses, Girandoles, Jardinières, Consoles*, 1878

Hugh Wakefield, *Nineteenth Century British Glass*, 1961

Hugh Wakefield, *Victorian Pottery*, 1962

Patricia Wardle, *Victorian Silver and Silver-Plate*, 1963

Concise Encyclopaedia of Antiques, 1954–1961

The Official Catalogue of the Great Exhibition, 1851

The Official Illustrated Catalogue of the 1862 Exhibition

INDEX

Plate numbers are shown in bold face type